# TYPE & COLOR 2

## How to Choose and Specify Color Fades and Type & Color Combinations

BY
RICHARD EMERY

ROCKPORT PUBLISHERS • ROCKPORT, MASSACHUSETTS
DISTRIBUTED BY NORTH LIGHT BOOKS • CINCINNATI, OHIO

Copyright ©1994 by Rockport Publishers, Inc.

All rights reserved. No part of this book may be reproduced in any form without written permission of the copyright owners. All images in this book have been reproduced with the knowledge and prior consent of the artists concerned and no responsibility is accepted by producer, publisher or printer for any infringement of copyright or otherwise, arising from the contents of this publication. Every effort has been made to ensure that credits accurately comply with information supplied.

First published in the United States of America by:
Rockport Publishers, Inc.
146 Granite Street
Rockport, Massachusetts 01966
Telephone: (508) 546-9590
Fax: (508) 546-7141
Telex: 5106019284 ROCKORT PUB

Distributed to the book trade and art trade in the U.S. and Canada by:
North Light, an imprint of
F & W Publications
1507 Dana Avenue
Cincinnati, Ohio 45207
Telephone: (513) 531-2222

First Thailand edition 1994, published by
Rockport Publishers, Inc. for
Suriwong Book Centre Limited
54/1-5 Sri Donchai Road
Chiang Mai 50000
Telephone (053) 28-1052 to 5
Fax: (053) 27-1092

First Brazilian edition 1994, published by
Rockport Publishers, Inc. for
Casa Ono Comercio Ltd.
CEP 0547
Rua Frenao Dias, 492
Sao Paulo, Brazil
Fax: 01155 11813 6921

First U.K. edition 1994, published by
Rockport Publishers, Inc. for
B.T. Batsford Ltd.
4 Fitzhardinge Street
London W1H OAH

Other Distribution by:
Rockport Publishers, Inc.
Rockport, Massachusetts 01966

ISBN 1-56496-065-X

10 9 8 7 6 5 4 3 2 1

Designer: Richard Emery
Editor: Rosalie Grattaroti
Production Manager: Barbara States
Production Assistant: Pat O'Maley
Typesetting: Richard Emery

Printed in Hong Kong

## ACKNOWLEDGEMENTS

This project is the latest publication in a series of books produced by this publisher addressing the use of color in graphic design. Each book has naturally evolved from the one preceding it, and concentrates on one particular aspect of the application of color.

As before, there was considerable help and encouragement from the publisher. I would especially like to mention Stan Patey, Barbara States, and Pat O'Maley for their assistance in the coordination and production of this project. Their continuing availability and creative presence helped greatly in the process and I am much indebted to them.

## STAFF & CONTRIBUTORS

EDITOR/DESIGNER..........Richard Emery
ART ASSISTANT..........Karen Shea
PRODUCTION COORDINATORS..........Barbara States
                                                     Pat O'Maley

Cover Photo: David Benoit

**TYPE & COLOR 2 - *BLENDS***

# Contents

**FOREWORD.........9**

**HOW TO USE THIS NEW GRAPHIC TOOL.........12**
A guide to making TYPE & COLOR 2 work for you

**GREAT BLENDS.........21**
Examples of the application
of color blends to graphics

**TYPE & COLOR 2 SELECTOR.........39**

**BLENDS.........40**
100 pages of two, three and four-color
graduations that can be used as indications of
blend possibilities, and in conjunction with the
acetates, show the effects of color type on them.

**INSIDE BACK COVER**
2 acetates with opaque color type printed on them

# Foreword

One of the most gratifying aspects of the graphic design process is the discovery of the limitless, ever-changing possibilities that constantly present themselves to the designer. One needs merely to remain open to them, and new ideas will follow. This has always been the nature of good design and good designers. Yet, never has this been more evident than today. The media, both print and electronic, is now experiencing a creative explosion of new ideas and new approaches to visual communication. Just when an existing idea seems to have run its course something new and exciting leaps in to replace it.

Recently, I was challenged with the problem of working with a rather pedestrian piece of art that a client insisted must be used for identification purposes. This piece of art had been in use for years, and the possibility that this tired visual could be given new life seemed remote. But then a simple solution presented itself. Why not place an interesting graduated color background behind the art. Give it a field that is not only colorful but has movement as well. I had the advantage of being able to use the four process colors. So I looked through my color percentage charts to select a combination that would provide impact and movement. Then it occurred to me that a single graduated color from light to dark was not as effective as

one color graduating into another color. This then created the problem of how to visualize the effect of any decision that I might make.

I searched the bookshelves for some printed guide that would show color blends appropriate to the design I was working on. I found nothing in my extensive collection of art and design books that even mentioned blends let alone show actual applications. Thus began the arduous task of computer printouts, testing and matching results, followed by the final decision before making the presentation. This process did produce a striking image and gave real impact to the client's message.

The concern that I had after this experience was one of accessibility. I liked the final design very much, but questioned whether I wanted to go through the same process every time I wanted to recreate the effect. I questioned my fellow designers and poured through catalogs. There were no printed guides to be found anywhere. Nothing that would help in selecting color blends, or contribute in any way to the decision making process.

Previously, I had written a book on the use of overprinting transparent colors to create new colors, adding mileage to the limited use of two and three colors. It seemed that same approach might be possible for this idea of color graduations. If I had owned a reference book like that, I would have reduced my time by half as far as the selection process was concerned.

Thus you see before you the results of a concentrated effort on my part to solve the problem, and fill the void that seemed all too evident to me. I think that as you look through this book you will find it a very viable design consideration that is worthy of being in your repertoire,

and will simplify your decision making when the occasion arrises.

One of the first discoveries that came from developing this publication was the variety of applications uncovered. Each new use of graduated color seemed to introduce other equally viable applications, and the possibilities made this concept much more present in my own everyday work. Of course, the use of color fades is not meant to replace the responsibility of designers to fully consider their project from the standpoint of design. This is not a gimmick to bypass the design process, but rather a companion element to aid and enhance the larger concept. When taken in this light, the use of color in its many graduated forms becomes an exciting and dynamic part of the graphic design scheme, especially in allowing the designer to present a dramatic field upon which to place other design elements.

When using this book, the hope is that the readers will gain a sense of enhancement about their own work, and see this as a valuabe asset to the creative application of graphic design in the field of modern-day communications.

Richard S. Emery
President, Richard Emery Design, Inc.

**TYPE & COLOR 2 - *BLENDS***

# How To Use This New Graphic Tool

In the process of creating new graphic design ideas, one constantly confronts the problem of guaranteeing results that match the original concept. Often this happens when the designer does not have sufficient control of the reproduction process and must make decisions based on limited understanding of the possibilities. A perfect example of this is the use of graduated color fades as background behind graphics, objects, or text. A second and equally difficult task is to determine how color type will work when positioned within these backgrounds. These two considerations are the primary objectives of this book, and together they give us a dual-purpose design tool.

With the onset of electronic color pallets there is a growing interest in the potential generated by graduated color backgrounds. One of the obvious impediments to this is the designer's inability to visualize exactly how the graduation will look, and whether the color change will work well with its companion art. Also, when a choice is made, it is next to impossible to construct accurately what the screen combinations might be.

**TYPE & COLOR 2 - *BLENDS***

To answer these two concerns we have developed TYPE & COLOR 2 - *BLENDS*. First, this book is a tool that not only shows visually the effects of various color graduations, but also labels the percentage breakdowns of the colors so that the designer can confidently anticipate the results. Here we have reproduced 400 different color blends using combinations of the <u>four process colors</u>. Some utilize various two-color combinations of the four colors, some three, and some are complete with all four. This vast array of choices gives tremendous advantage to anyone wishing to upgrade their design project.

Secondly, we have included a pocket inside the back cover (as we did in TYPE & COLOR 1) with acetates that are printed with various lines of type in different opaque colors to show how color type works within a graduated color background. You can take out these two acetates and place them over the many fades reproduced here and make your own judgment as to color choices.

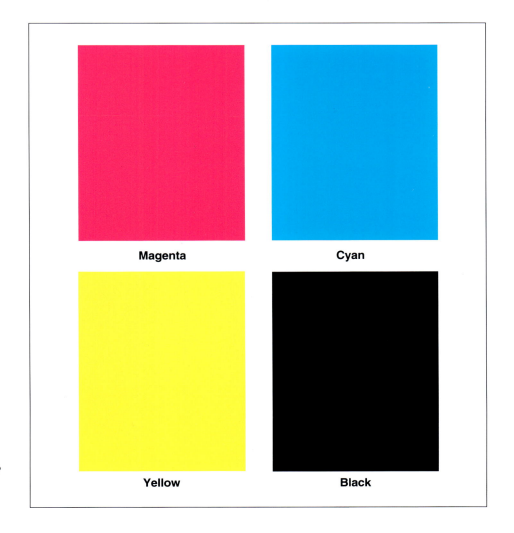

**Fig. 1. The four process colors used to create the color graduations in this book.**

# TYPE & COLOR 2 - *BLENDS*

On the following pages you will first see excellent examples of design work that fully utilize this effect. Following this section you will find the main body of this publication: 400 color fades and graduations, each with a sufficient color area to fully visualize its effect, and each documented with the screen values used.

## How to view the blends and understand the method of calibration

As we have mentioned, the examples of color graduation in this book have been created entirely with combinations of the four process colors (cyan, magenta, yellow, and black), *Fig. 1*. The first series of fades utilizes combinations of two colors at a time, *Fig. 2*, and is followed progressively by three and four-color examples, *Figs. 3 & 4*, to show the diversity and wide range of possibllities inherent in this process.

Along the left side of each example we have callibrated the degree of change of each color as the graduation progresses from top to bottom, *Fig. 5*. Thus you can determine the exact screen combinations anywhere along the color band as it changes from one shade to another. Each of the calibrations are printed in their representative color. For example,

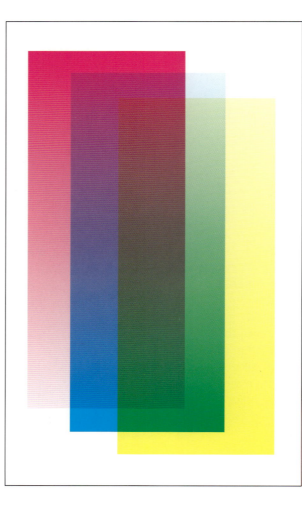

***Fig. 2. (left) example of two process colors overprinting to create a color blend.***

***Fig. 3. (right) example of three process colors overprinting to create a color blend.***

when the color cyan is graduating from 0% intensity at the top to 100% intensity at the bottom, you will find these numbers and the calibrations of 20%, 40%, 60%, and 80% printed in cyan at their appropriate locations along the side of the band. We have also done this with the other three colors, thus letting you know where you are on any given spot on any given band, *Fig. 6.*

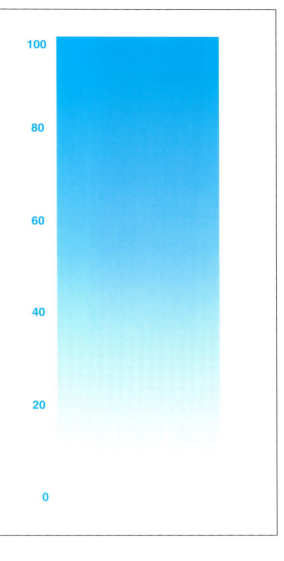

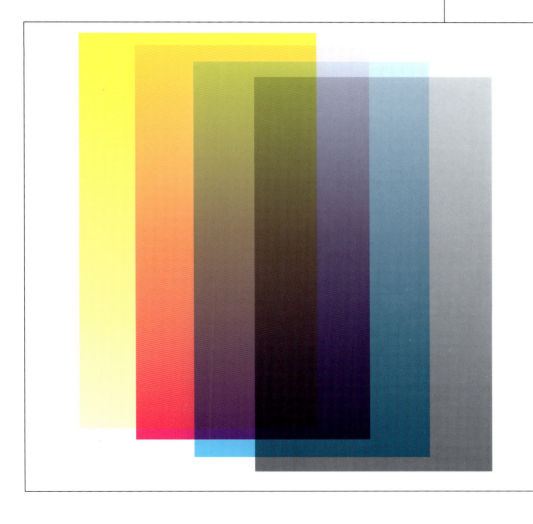

*Fig. 4. (left) example of four process colors overprinting to create a color blend.*

*Fig. 5. (right) example of the callibration method used to show degree of blend in each color.*

# TYPE & COLOR 2 - *BLENDS*

Some of the graduated effects created here require that some of the colors not change in intensity. For example, you might be graduating the colors cyan and magenta while holding the color yellow at a constant percentage. Thus you would see the cyan and magenta calibrated down the side of the band, and beneath the band at the bottom of the page you would find the constant unchanging percentage of yellow that overprints the entire band, *Fig. 7*.

This also means that when you place an acetate of color type over a band you can tell at what calibrated point the type reads best and at what point it begins to lose its legibility. (Nobody likes illegible type.) This is a decided advantage to designers, allowing them to utilize this effect with confidence.

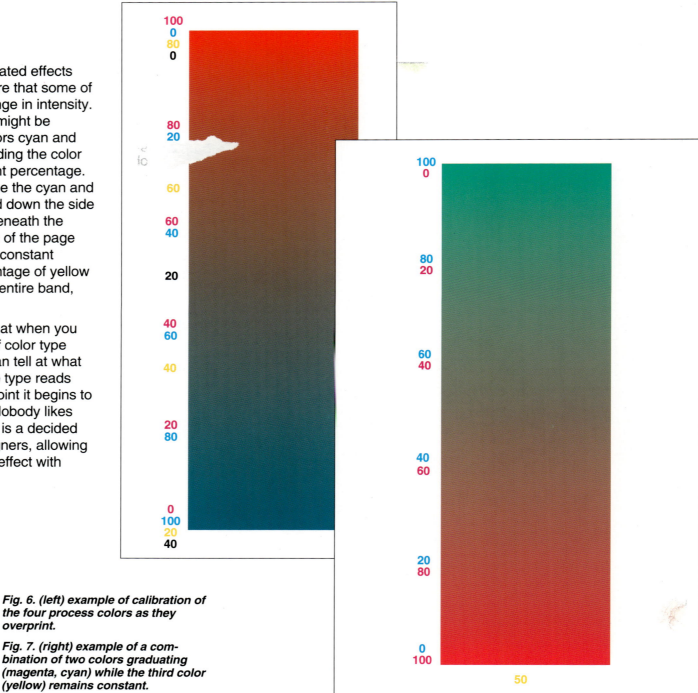

**Fig. 6. (left) example of calibration of the four process colors as they overprint.**

**Fig. 7. (right) example of a combination of two colors graduating (magenta, cyan) while the third color (yellow) remains constant.**

**TYPE & COLOR 2 - *BLENDS***

# DESIGN IS THE TRUE VEHICLE FOR VISUAL COMMUNICATION

*With the proper consideration of design possibilities and the intended message much can be accomplished.*

**Graphic design is the historical business of visual communication. All the various stories and messages that have been visually presented have needed the added attention of communicators who understand true enhancement through clarity and appearance. This has been the task of all graphic designers since the beginning of the printed word, and because of the present media explosion, it is even more important today.**

## Uses and applications

As you will see when you look over the pages of printed examples that follow, there are many ways to utilize the effect of graduated color. The first and most obvious application is to place a graduated background behind a page of typography that would otherwise be dull and unattractive since there are no graphics to accompany it, *Fig. 8*. This in effect becomes a graphic device that adds interest and movement to an otherwise static image. This fade can either bleed off the printed page or be framed in a white border. With variations of placement and border colors, you are presented with a number of options.

Another application would be the use of color graduation on an existing piece of line art or graphic. It could appear as a background behind the art, *Fig. 9*, or the art could act as a window for the color change. This would make what had previously been black line art into colorfully graduated line art, *Fig. 10*. This works especially well with large typographical headlines. The type gradually changes color from left to right and seems to have a life of its own, *Fig. 11*.

*Fig. 8. example of color-graduated background placed behind existing typography.*

TYPE & COLOR 2 - *BLENDS*

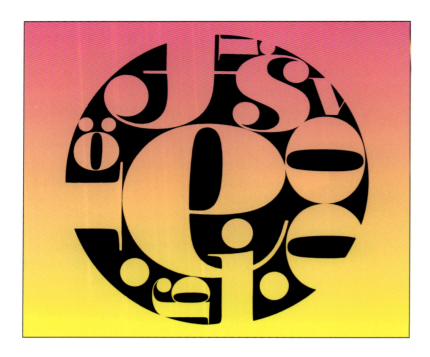

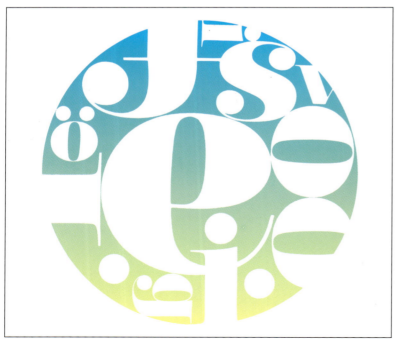

# LET'S ALL SING PRAISES TO THE PRINTED PAGE!

*Fig. 9. (top left) example of color graduation placed behind existing line art.*

*Fig. 10. (bottom left) example of line art that has been converted to a color blend.*

*Fig. 11. (top right) example where typography is used as the line art for a color blend.*

A third and extremely effective use of color fades is as a background behind an existing silhouetted product shot, *Fig. 12*. This works well whether the photograph is in black and white or in full color. The original photograph may have a white background or a color or graduation that was unsuccessful. Whatever the existing background is, it is undesirable, and the product image can be silhouetted out and placed over an appropriate color fade selected from the many examples shown in this book.

The possibilities seem limitless whether you are spotting a chosen fade within your design or combining more than one of them in a multi-image concept, *Fig. 13*. Whatever you decide, you will find this a helpful double-faceted tool that is tailor-made for your design work. We know that you will appreciate its uniqueness when you begin to use it, and will find it indispensible.

The only cautionary hint in specifying color fades has to do with single color printing and the quickness of the graduated change. Sometimes when creating a fade with only one ink and with a dramatic movement from dark to light in a very short space, striations can appear in the dot pattern. Multiple color overprints tend to smooth out and compensate for any irregularities.

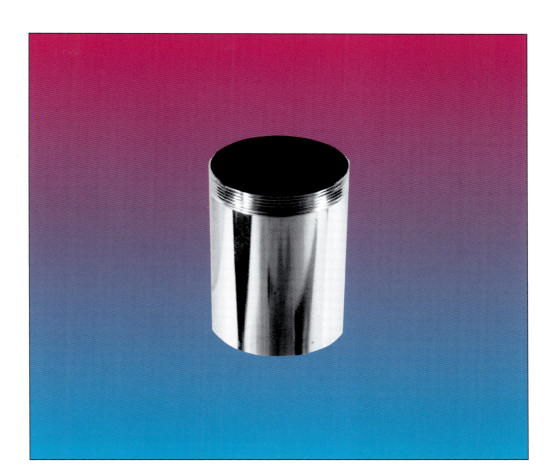

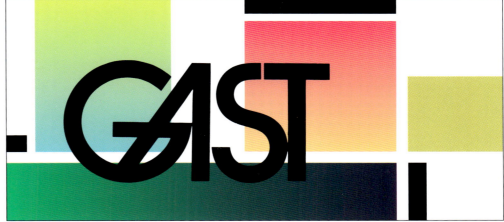

*Fig. 12. (top) example of a color-graduated background surrounding a silhouetted photograph.*

*Fig. 13. (bottom) example of a multi-image design using more than one color blend.*

## How to Choose and Specify Color Blends and Type & Color Combinations

# GREAT BLENDS

It is necessary to see actual examples of how color graduations are used professionally to fully appreciate the range of expression that this technique offers. The following pages show many pieces submitted by professional designers. They have been selected to show the maximun impact of color transition. The graduated color effect has been used for some time in graphic design, but only recently with the advent of computer generated graphics has the scope of its application been fully appreciated. The very fact that color graduations can be scanned through the computer in any graduated format and in any combination of colors leads the designer to experiment and reach out far beyond any previous imaginings. These examples represent more than one reproduction process, but they give a clear indication of what can be achieved with graduated colors.

As you look at the examples notice the variety and impact they have. Notice the freedom that designers are now experiencing. But most of all notice that these designers have not let the technique obscure the basic design or the message intended.

Check out these pages before you enter the main part of this book. They will give you direction and confidence as you begin your own applcations.

TYPE & COLOR 2 - *BLENDS*

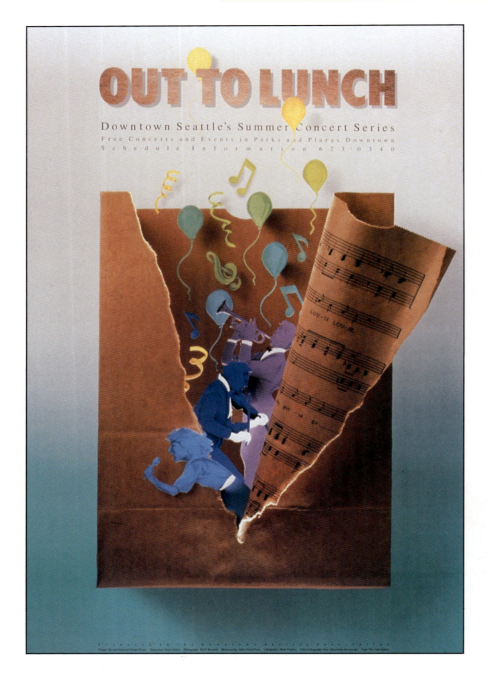

Downtown Seattle Association
Hornall Anderson Design Works, Inc.
Jack Anderson, art director/ designer
Mary Hermes, designer
Photography, Mark Burnside
Illustration, Nancy Gellos

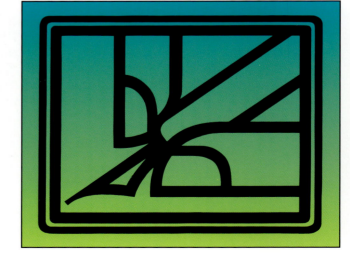

Richard Emery Design, Inc.
Richard Emery, designer
Self promotion piece

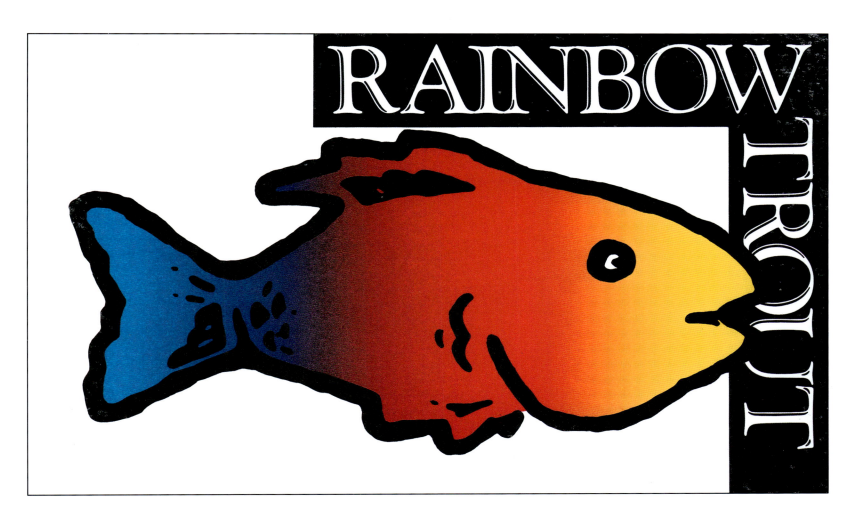

The Pier Restaurant
Sayles Graphic Design
John Sayles, designer

TYPE & COLOR 2 - *BLENDS*

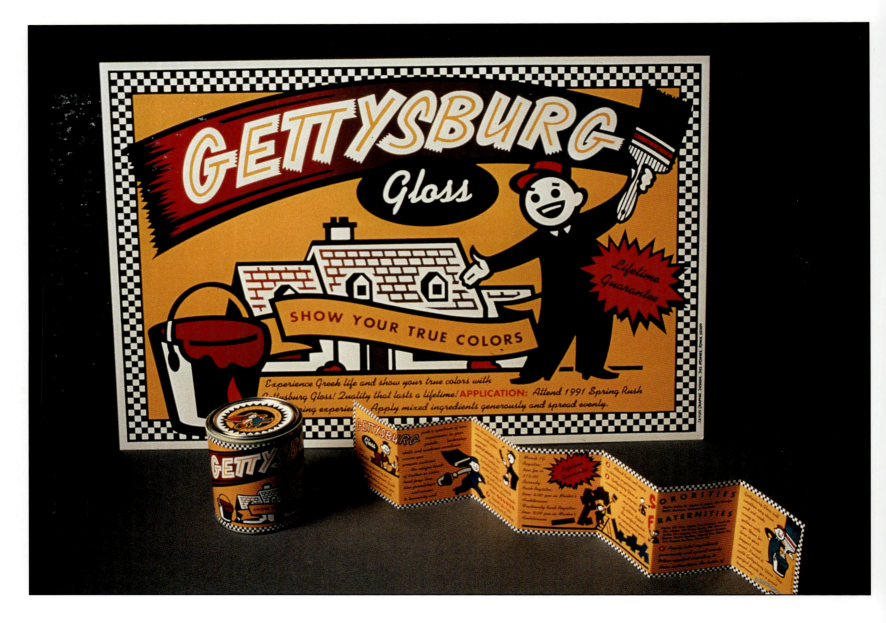

Gettysburg College, Pennsylvania
Sayles Graphic Design
John Sayles, designer

**TYPE & COLOR 2 - *BLENDS***

Landmark Calendars
Tracy Sabin Illustration & Design
Tracy Sabin, illustrator

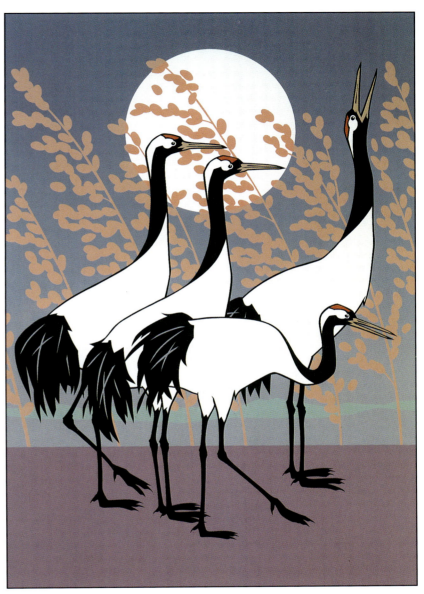

Mirage Editions
Karl Bornstein, art director
Tracy Sabin, illustrator

TYPE & COLOR 2 - *BLENDS*

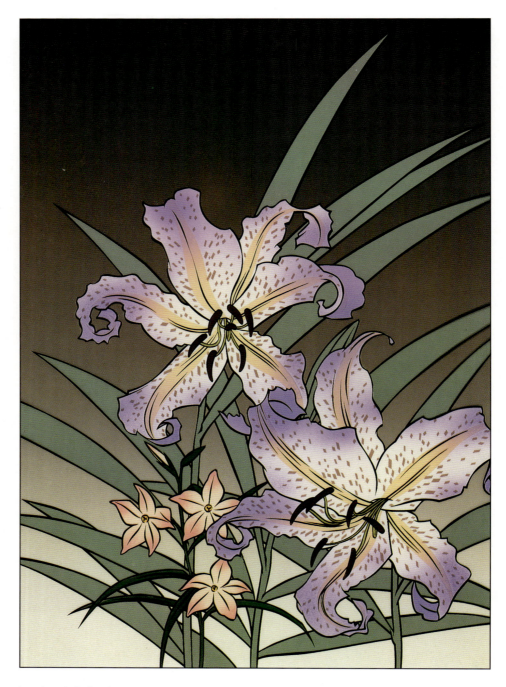

Landmark Calendars
Tracy Sabin Illustration & Design
Tracy Sabin, illustrator

TYPE & COLOR 2 - *BLENDS*

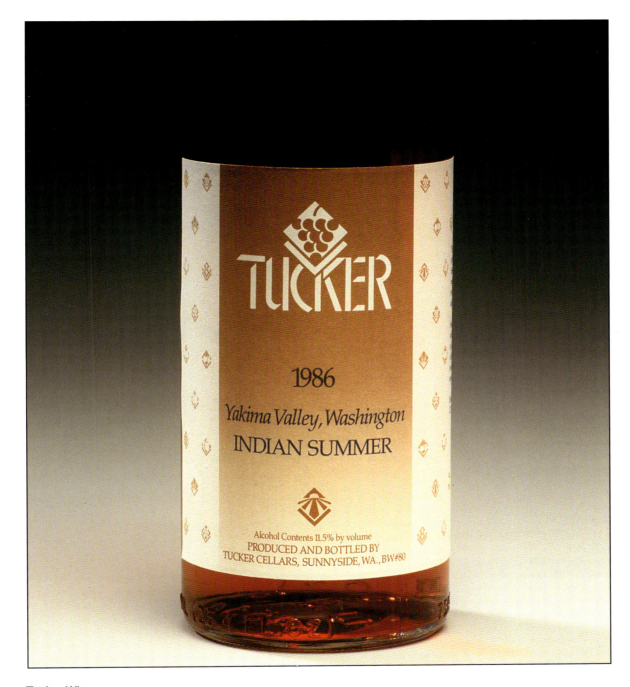

Tucker Winery
Rick Eiber Design
Rick Eiber, designer

**TYPE & COLOR 2 - *BLENDS***

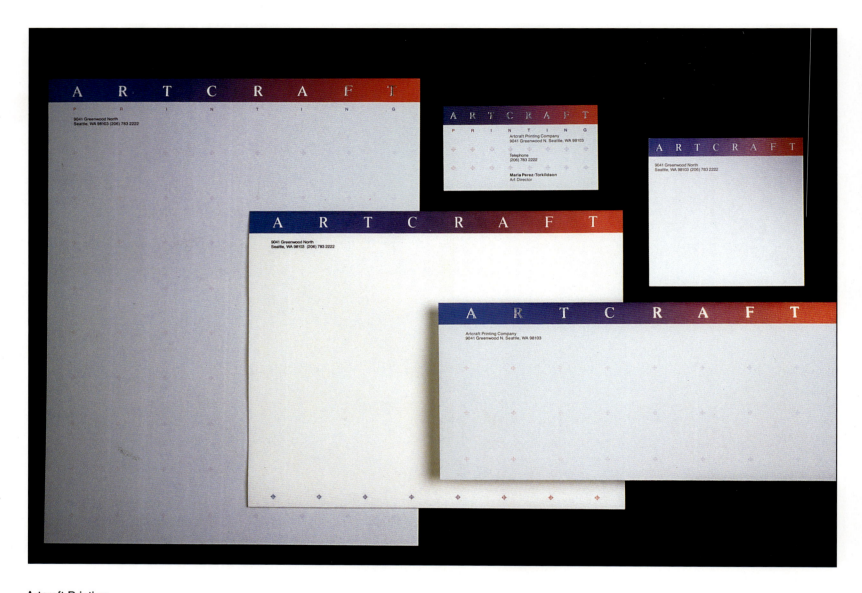

Artcraft Printing
Rick Eiber Design
Rick Eiber, designer

The King County Arts Commission
Rick Eiber Design
Rick Eiber, designer

Siggraph '80
Rick Eiber Design
Rick Eiber, designer

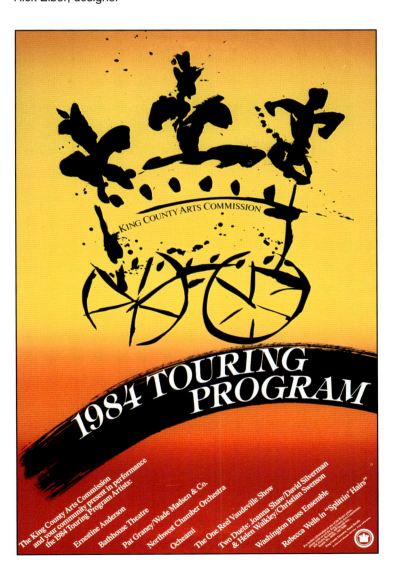

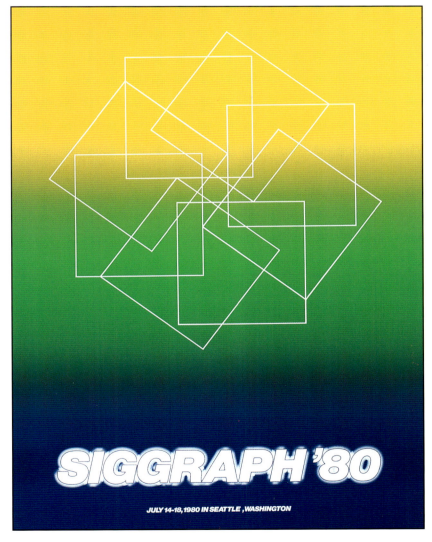

# TYPE & COLOR 2 - *BLENDS*

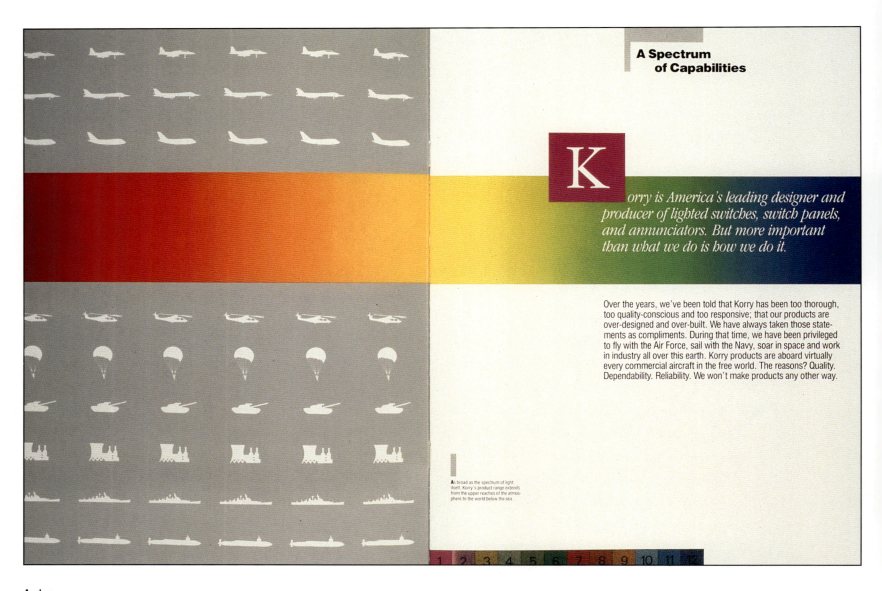

Ardco
Rick Eiber Design
Rick Eiber, designer

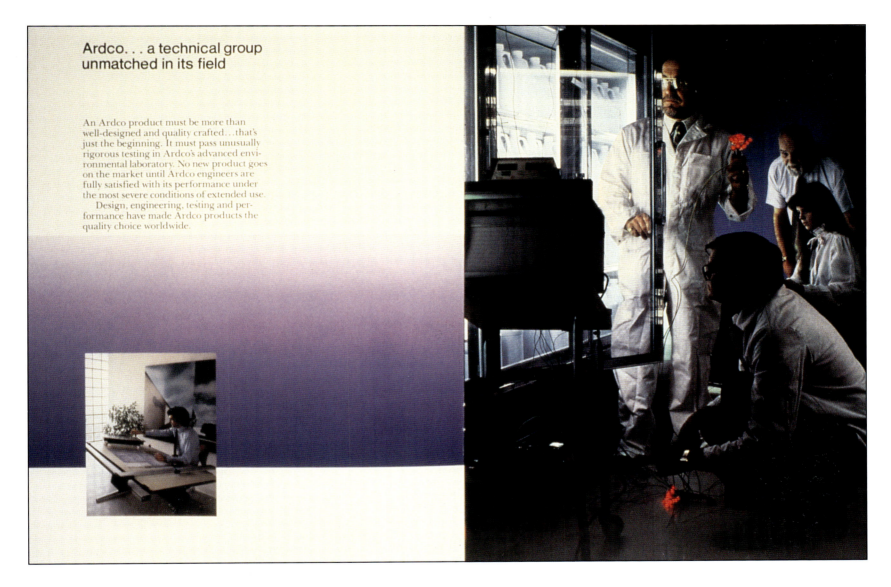

Ardco
Rick Eiber Design
Rick Eiber, designer

**TYPE & COLOR 2 - *BLENDS***

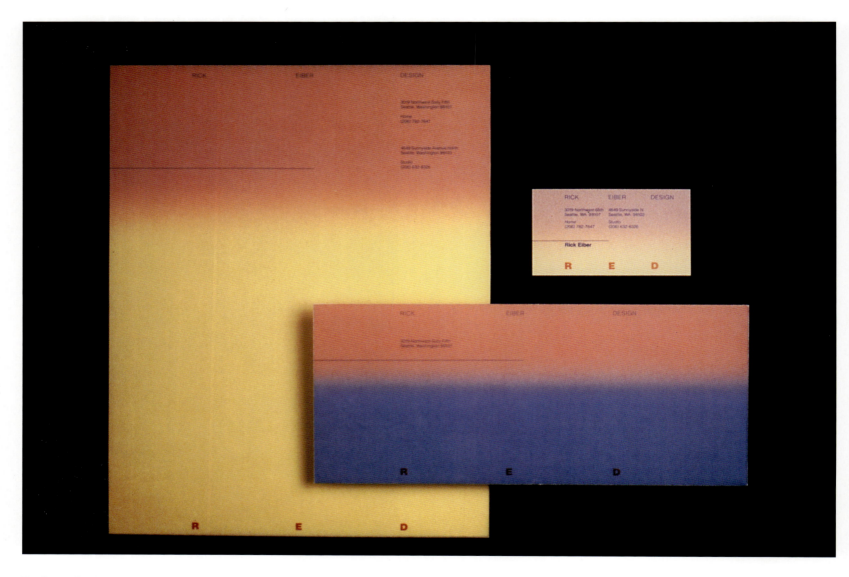

Business Stationery
Rick Eiber Design
Rick Eiber, designer

## TYPE & COLOR 2 - *BLENDS*

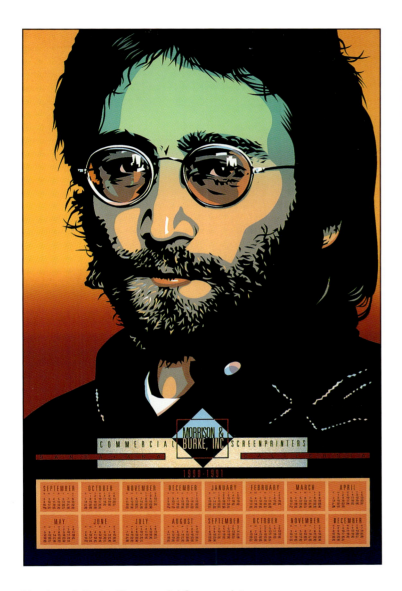

Morrison & Burke Commercial Screenprinters
Tom Morrison & Tom Burke, art directors
Tracy Sabin, illustrator

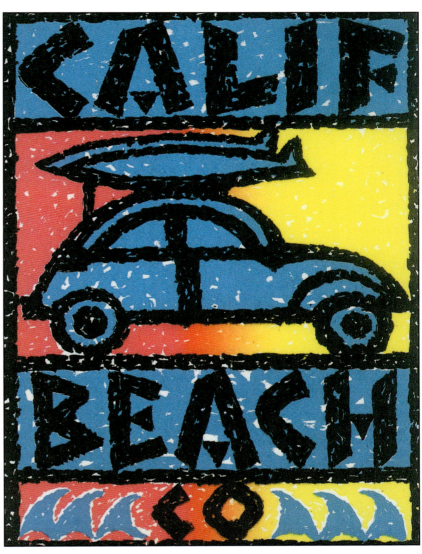

California Beach Co.
Richard Sawyer, art director
Tracy Sabin, illustrator

**TYPE & COLOR 2 - *BLENDS***

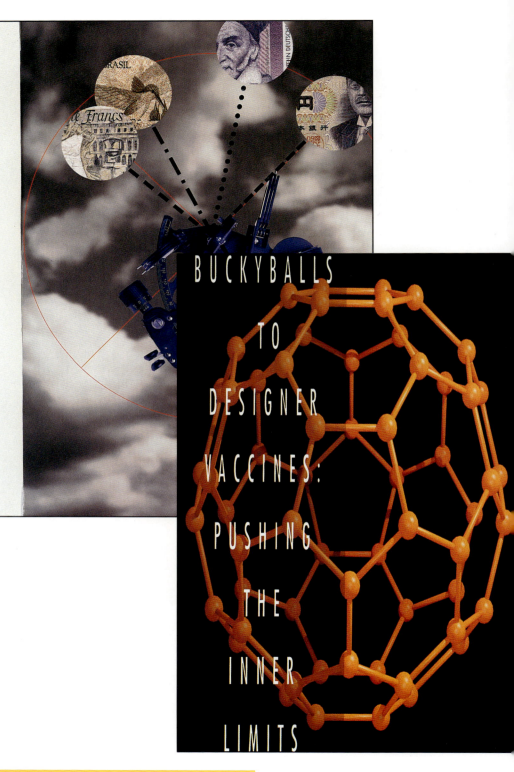

Millipore
Weymouth Design, Inc.
Tom Laidlaw, designer

"Millipore is collaborating with the Danish scientists who developed peptide nucleic acids, or PNA. The new molecule has some advantages over its DNA cousin and promises breakthrough applications in research, therapeutics and diagnostics."

Dr. Nanda Sinha (left), scientist at Millipore, confers with Dr. Michael Egholm, who discovered PNA with his colleagues at the H.C. Ørsted Institute at the University of Copenhagen.

Not many years ago, there was something called "pure research." The cycle of scientific research and discovery often remained more or less disassociated from practical applications. Eventually, commercialization would catch up to the discovery and trigger a so-called "race to market."

Today, commercialization and basic research play leap frog with each other. The race to market starts with — or even before — the scientific breakthrough. By providing innovative tools for emergent research in the materials and life sciences, Millipore not only shares in the exhilaration of discovery; it also positions itself for a leading role in the inevitable practical applications of the research.

### BUCKYBALLS, THE SECRET LIFESTYLE OF THE CARBON ATOM

When *Science* magazine named the Buckminsterfullerene ($C_{60}$) as Molecule of the Year, the Editor expressed tongue-in-cheek shock that, "... an old reliable friend, the carbon atom, has for all these years been hiding a secret lifestyle." The geodesic-dome shaped fullerenes, or buckyballs, were discovered in 1985, and immediately began to fascinate and fuel the curiosity of chemists, physicists and materials scientists.

Graced with almost incredible symmetry, fullerenes show a number of intriguing physical properties. The molecule is extremely resistant to shock, suggesting its use as a space age lubricant. It shows evidence of superconductivity, a surprising revelation that could open up fruitful new paths of research. Some physicists even believe that the buckyball may be the long-sought added ingredient that will make diamond film a practical reality.

**Scanning electron micrograph of Millipore's patented virus-removal membrane, used to eliminate viral contamination from genetically derived biopharmaceuticals. The SEM shows a cross-section of this unique composite membrane.**

Developing these ideas requires sensitive and sophisticated analytical tools. Enter Millipore. At the forefront of buckyball-research, with metal complexes and buckyball modifications, new Waters HPLC detection capabilities have proven extremely useful. Waters photo diode array detectors give a 3-D spectral analysis of a sample, enabling a researcher to get more data out of the same research step. Researchers at Rice University, where buckyballs were first discovered, have noted that without 3-D spectral data they are "shooting blind".

Also, bridging the gap between the theoretical and the practical requires buckyballs in pure form, lots of buckyballs. Again enter Millipore. Researchers at the University of Kentucky have found Waters gel permeation chromatography to be a superior method for the preparative purification of $C_{60}$ and $C_{70}$ fullerenes. The method is simpler, uses less solvent, and produces more buckyballs.

### DNA WITHOUT THE D

Danish molecular biologists have "invented" a new form of DNA. Using advanced computer modeling techniques, they succeeded in building a peptide-based backbone that replaces the phosphate-sugar backbone in each strand of the familiar DNA double helix.

The new analog, called PNA, shares most of the character traits of naturally occurring oligonucleotides. However, in certain important respects, it's even better. Unlike DNA, the water-soluble, non-charged PNA molecule may readily pass through cell membranes, making it ideal for therapeutic uses. On the shelf, the totally synthetic PNA is also more stable and, unlike its natural cousin, is apparently not subject to biological degradation.

Most promising of all, PNA has been shown to bind to DNA even more strongly than other DNA does. For pharmaceutical use, this implies more effective drug delivery and lower dosage requirements. More exciting still, it opens the door to breakthrough advances in the field of diagnostics, where potential benefits include enhanced detection sensitivity, and the possibility of PNA-based diagnostic kits for a wide range of conditions.

While the full implications of the PNA molecule yet remain to be discovered, Millipore has acquired an exclusive worldwide license to market reagents for PNA synthesis, and to sell and license PNA oligomers for research applications. Amid the intense interest in this exciting discovery, Millipore is not only assisting in core research, but has already assumed a leadership role in realizing PNA's full commercial potential.

### DESIGNER LABEL VACCINES

AIDS and HIV-related diseases have sparked a revolution in the fields of virology and vaccine development. Drawing on recent breakthroughs in genetic engineering and immunology, scientists are now exploring innovative and promising strategies for designing anti-viral therapeutics and new vaccines. Millipore products and technologies impact these discoveries from R&D to manufacturing.

Traditional vaccine development starts with an infectious agent. It is isolated and then mutated in such a way as to render it harmless. Another approach is to use key components of the pathogen, called antigens, to trigger an immune response. In either case, the goal is to mimic an actual infection in the body; in effect, to trick the immune system into producing an amazing army of defenders — antibodies, T-lymphocytes and others.

Today, molecular biologists are using genetic engineering tools not only to shorten the vaccine development cycle, but also to make the process safer and more reliable. They begin by isolating from infectious pathogens the individual genes that con-

**TYPE & COLOR 2 - *BLENDS***

California Beach Co.
Richard Sawyer, art director
Tracy Sabin, illustrator

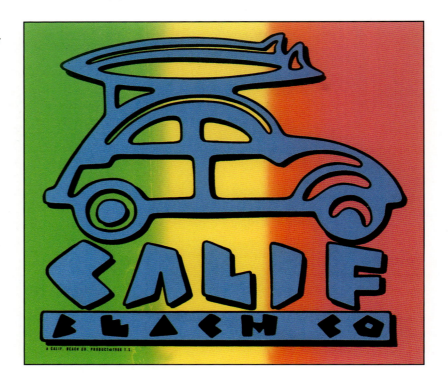

Japanese Village Plaza
Nicky Harvey, art director
Tracy Sabin, illustrator

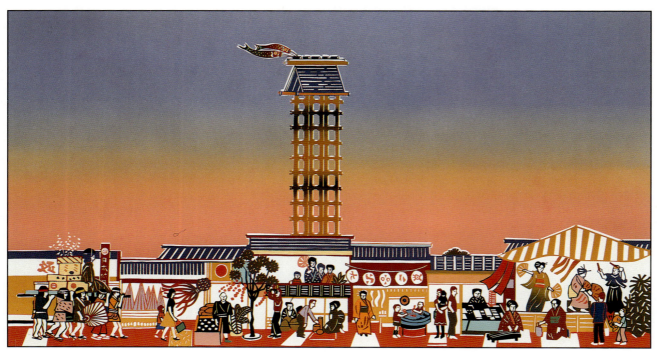

**TYPE & COLOR 2 - *BLENDS***

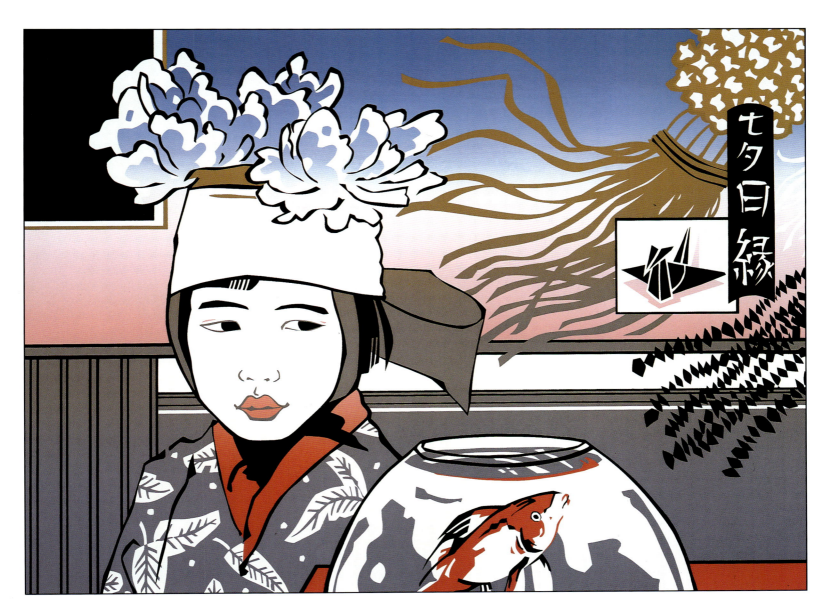

Japanese Village Plaza
Nicky Harvey, art director
Tracy Sabin, illustrator

**TYPE & COLOR 2 - *BLENDS***

*How to Choose and Specify Color Blends and Type & Color Combinations*

# SELECTOR

Here is the section of the book we've been talking about. There are 400 color graduations presented here that show the wide range of fade possibilities. After showing you the basic process colors in graduated form, we proceed to give you combinations of two, three, and then four colors. It is in fact true that even with these 400 examples we have barely touched on the vast numbers of combinations possible, and we leave it up to you to adjust any of the fades shown here to create new or slightly altered colors. What we have done here is display some of the more obvious and usable combinations hoping that they will provide you with the stimulus to use them and/or any of your own adjustments to give dynamic energy and movement to your own design work.

So once again we welcome you to another look at the fascinating world of color. Please take the time to check over all of the fades printed here, as they are truly remarkable examples of the range of color graduation.

**TYPE & COLOR 2 - *BLENDS***

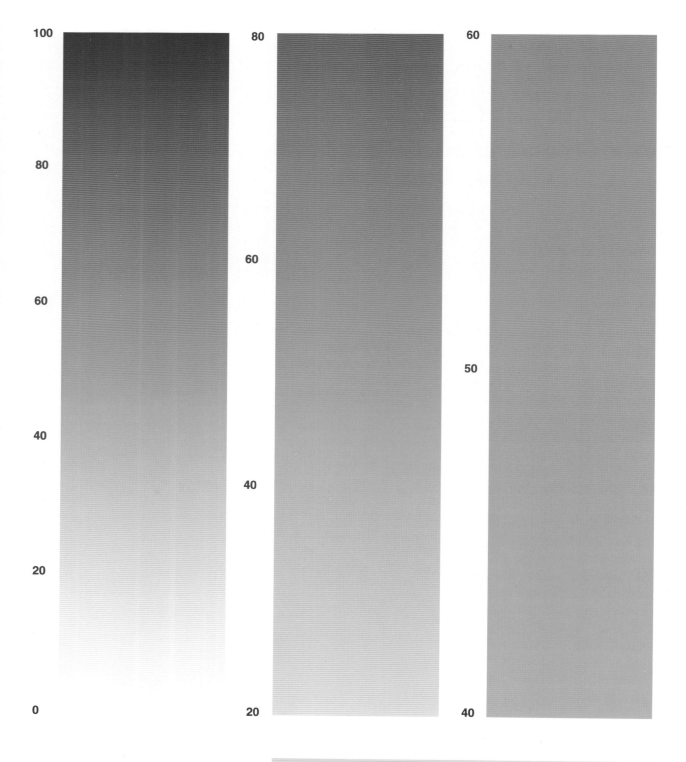

## TYPE & COLOR 2 - *BLENDS*

## TYPE & COLOR 2 - *BLENDS*

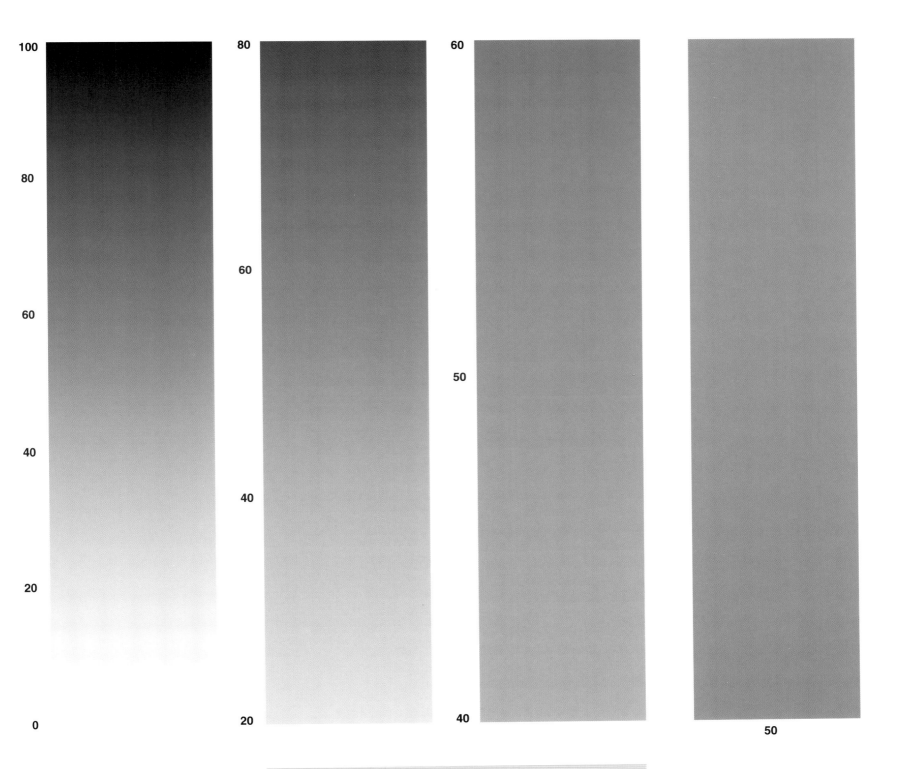

43

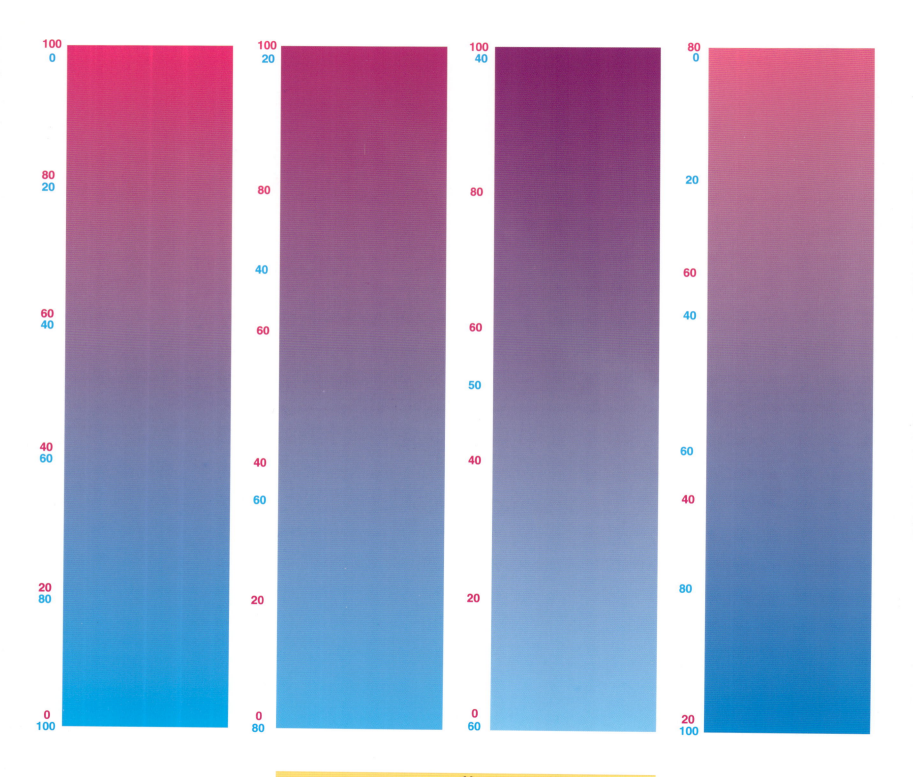

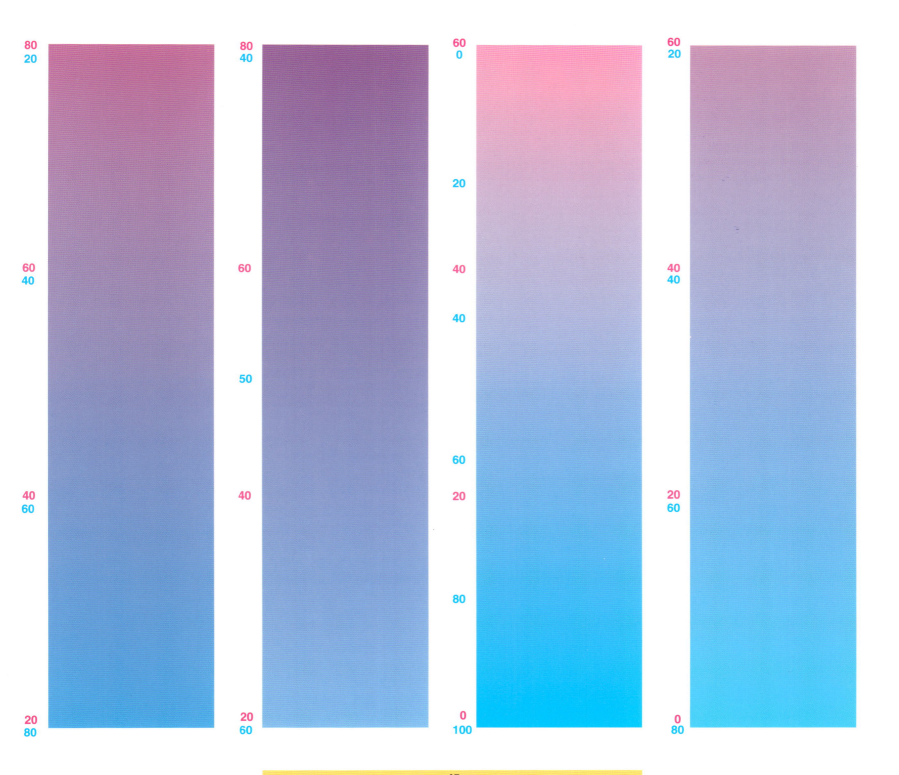

TYPE & COLOR 2 - *BLENDS*

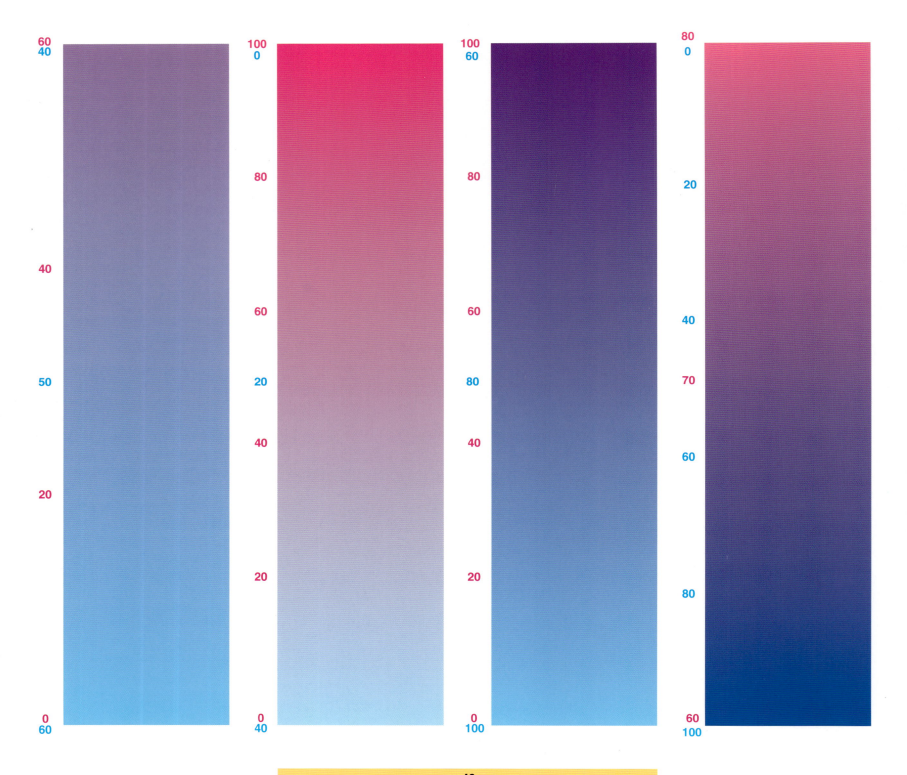

46

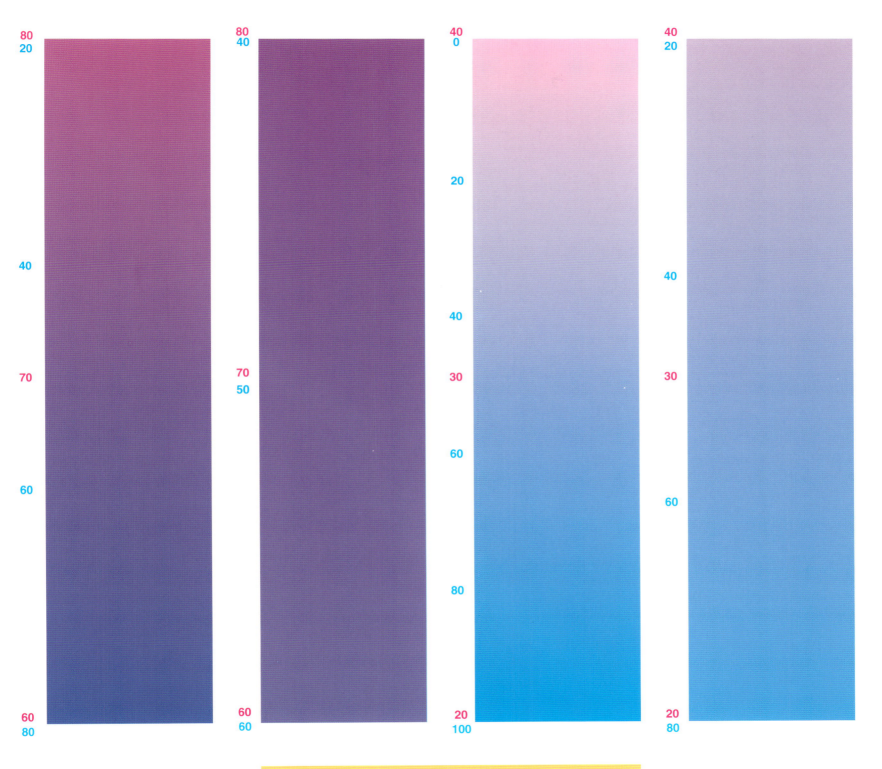

**TYPE & COLOR 2 -** *BLENDS*

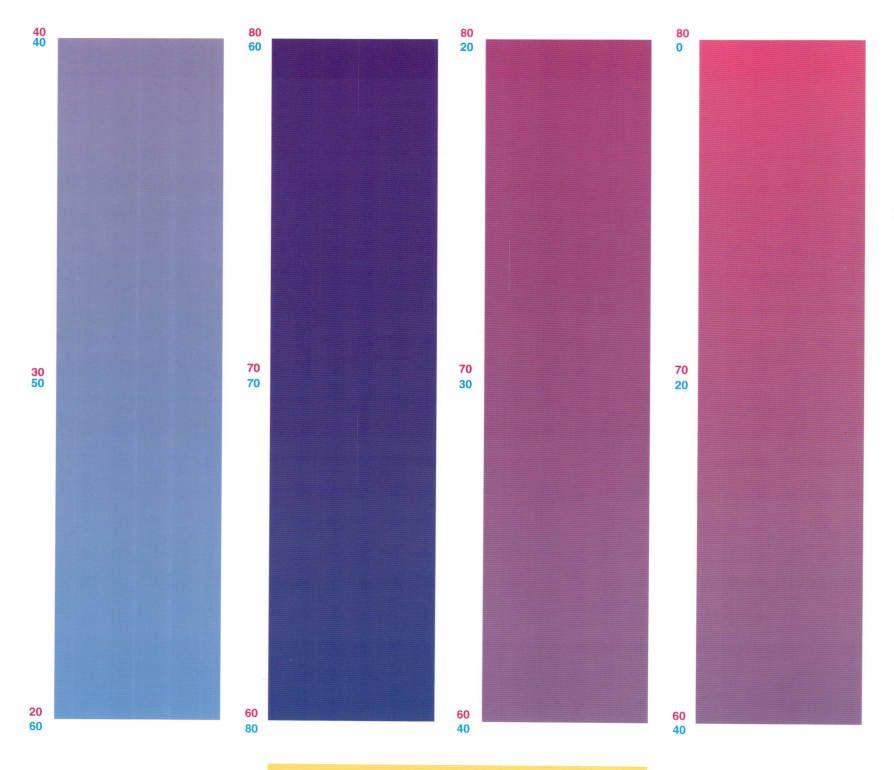

48

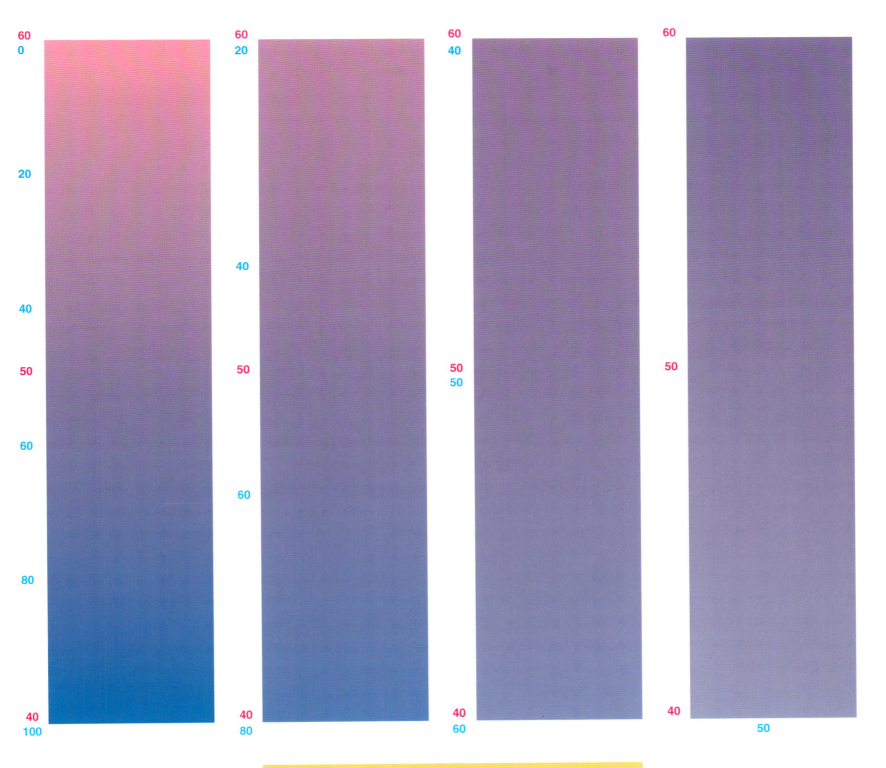

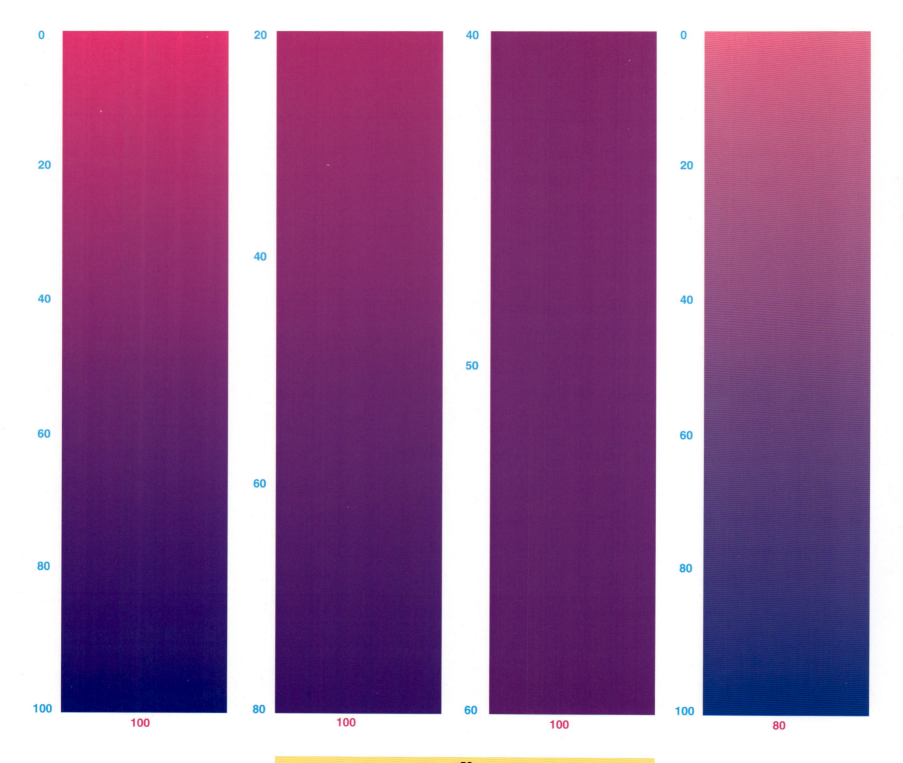

# TYPE & COLOR 2 - *BLENDS*

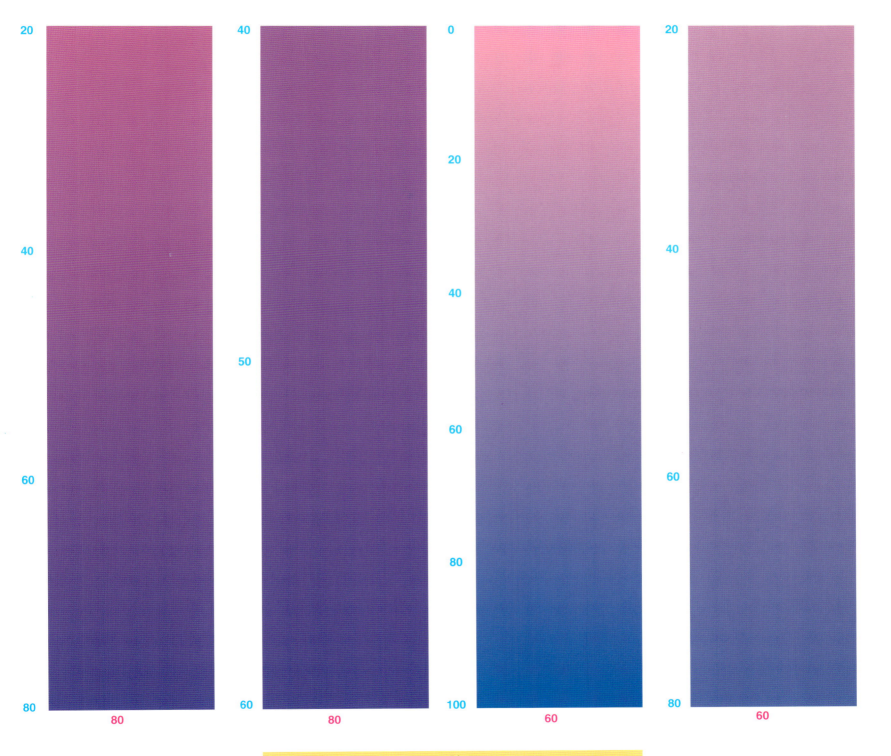

51

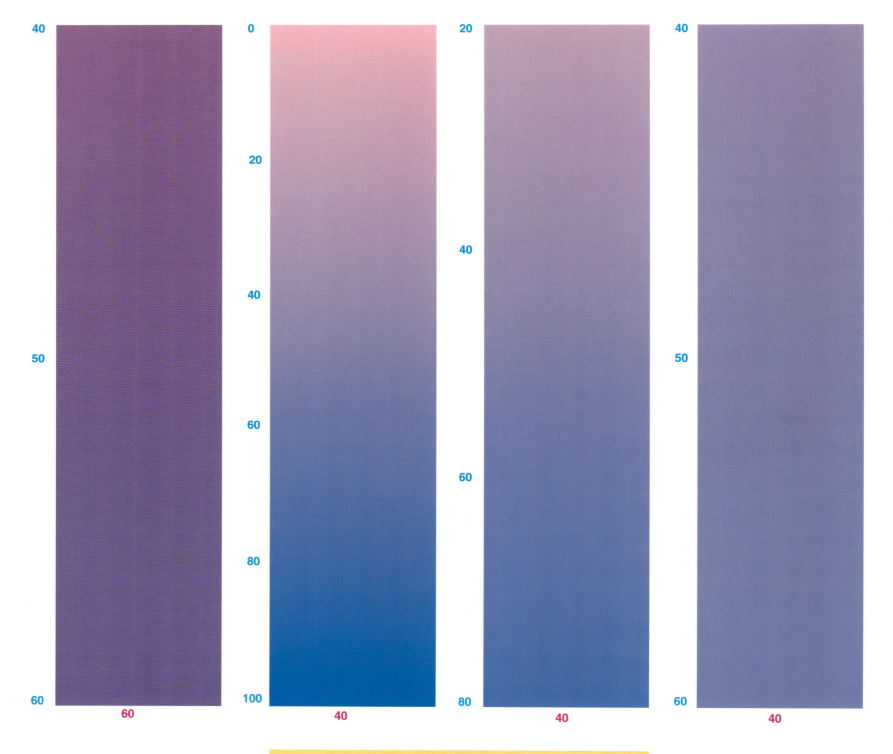

**TYPE & COLOR 2 - *BLENDS***

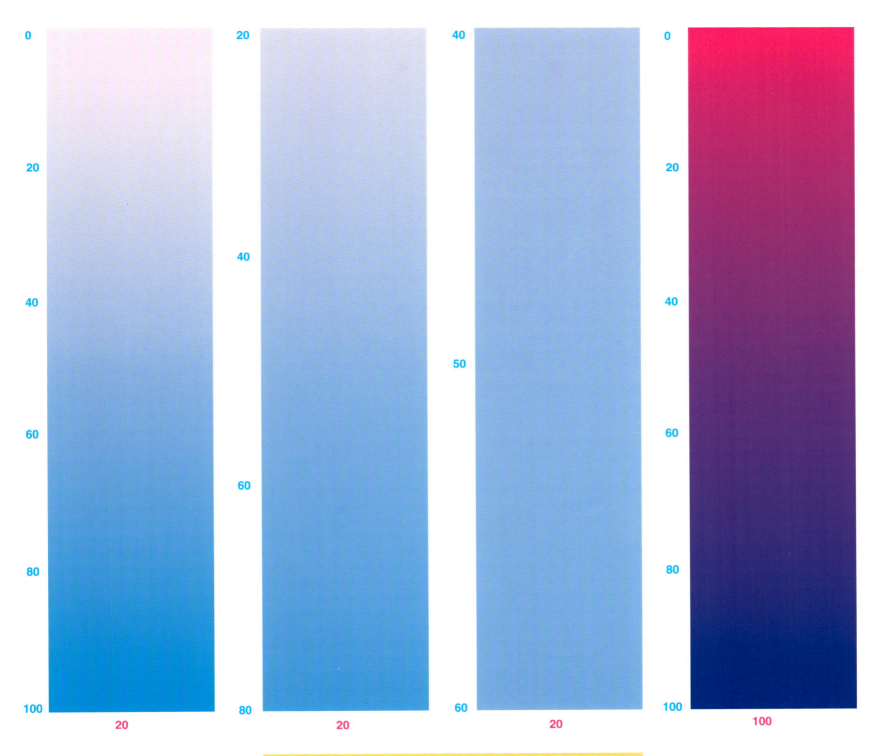

53

**TYPE & COLOR 2 - *BLENDS***

54

# TYPE & COLOR 2 - *BLENDS*

55

# TYPE & COLOR 2 - *BLENDS*

56

# TYPE & COLOR 2 - *BLENDS*

57

# TYPE & COLOR 2 - *BLENDS*

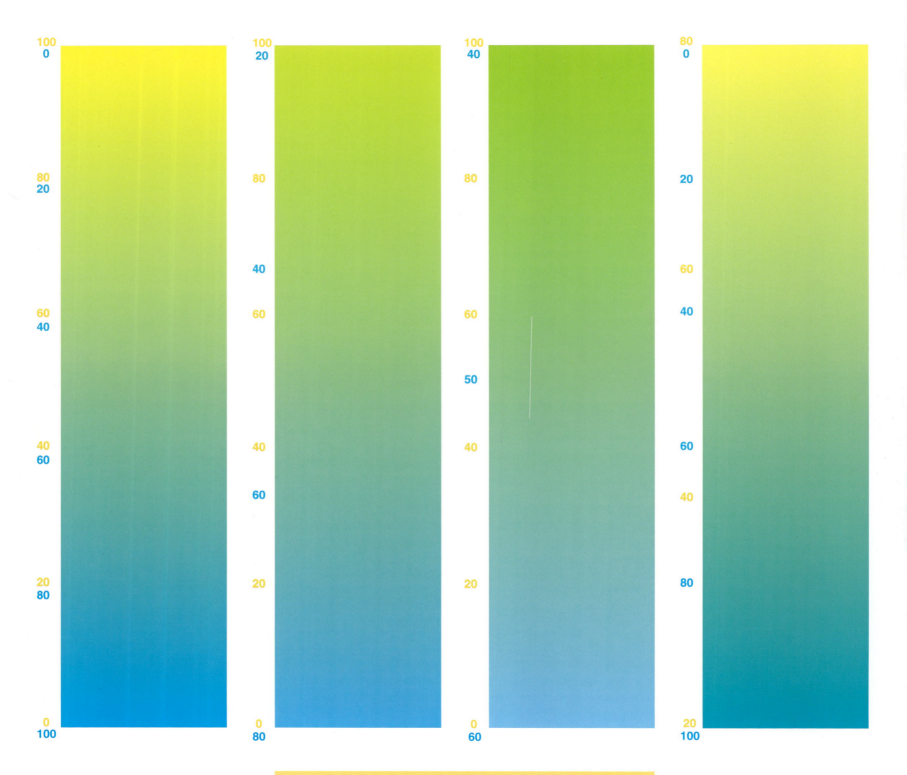

# TYPE & COLOR 2 - *BLENDS*

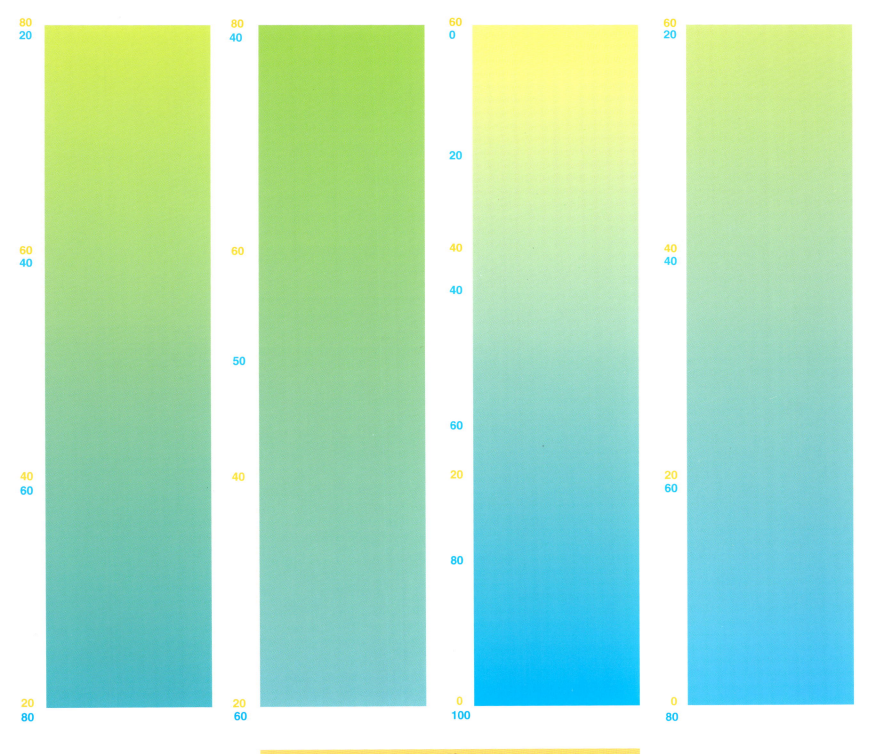

59

**TYPE & COLOR 2 - *BLENDS***

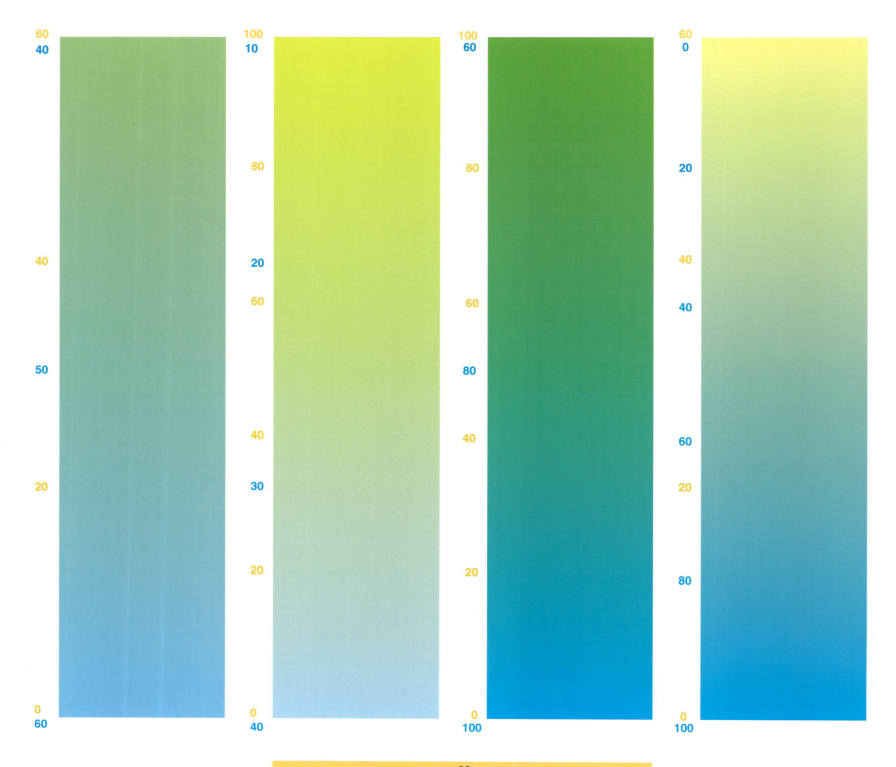

**60**

# TYPE & COLOR 2 - *BLENDS*

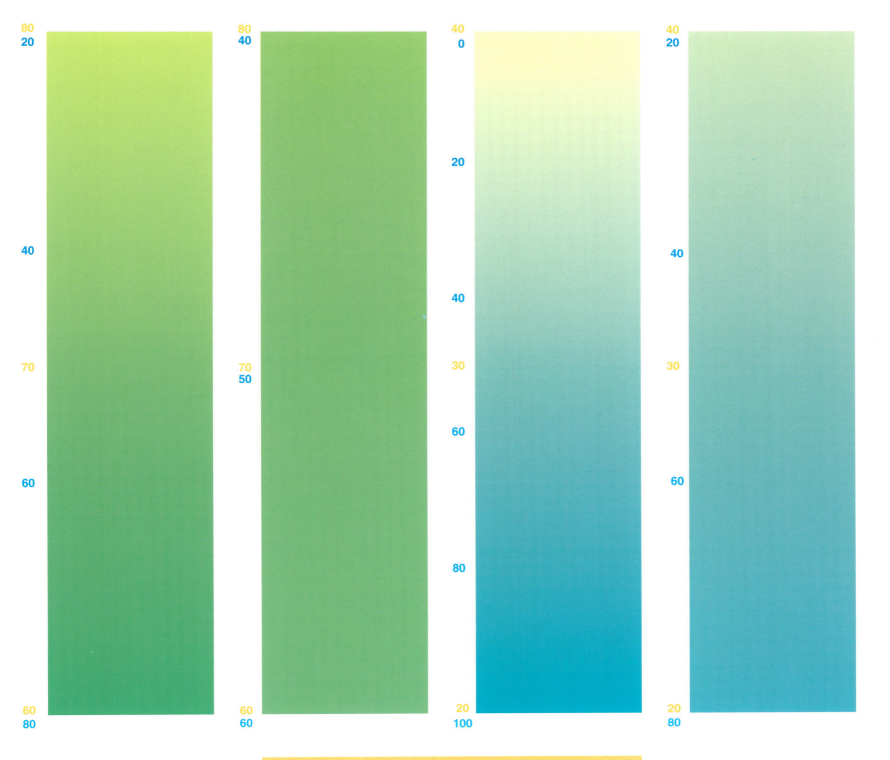

**TYPE & COLOR 2 - *BLENDS***

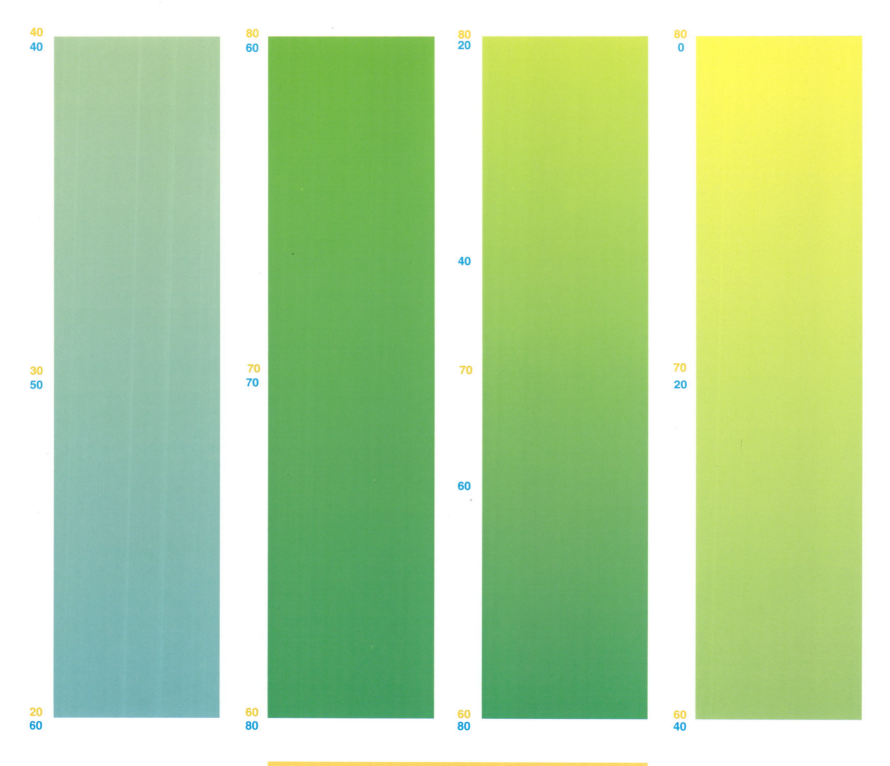

62

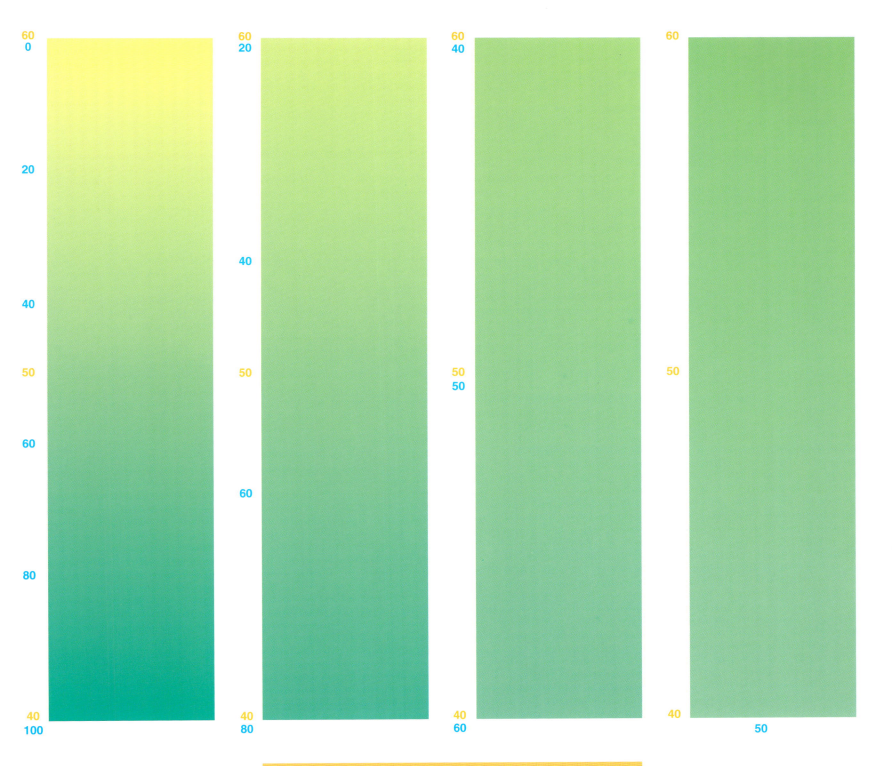

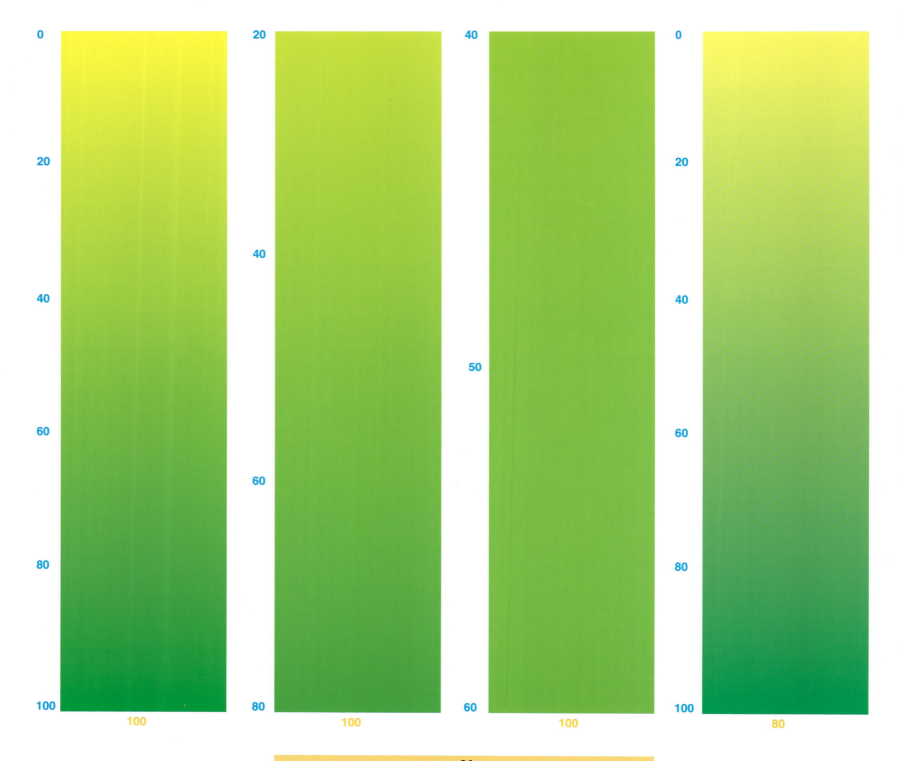

# TYPE & COLOR 2 - *BLENDS*

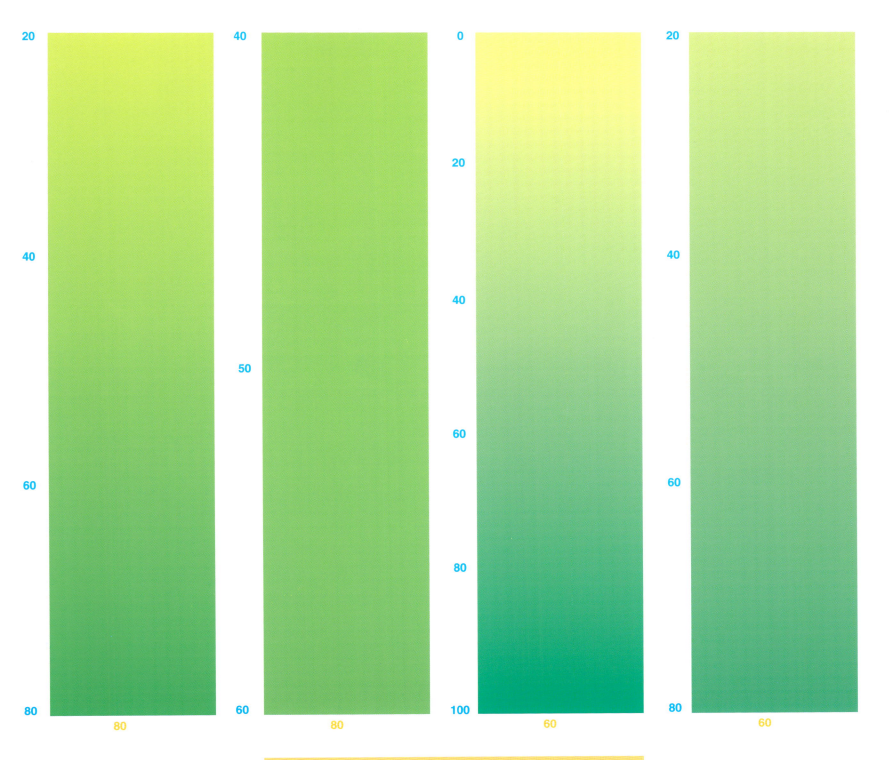

65

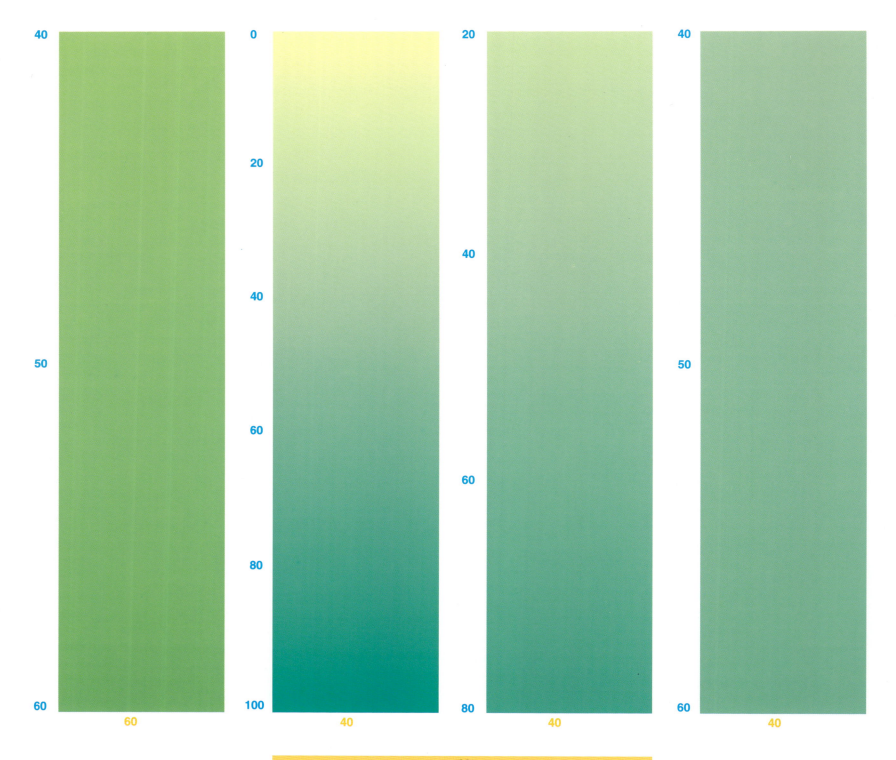

# TYPE & COLOR 2 - *BLENDS*

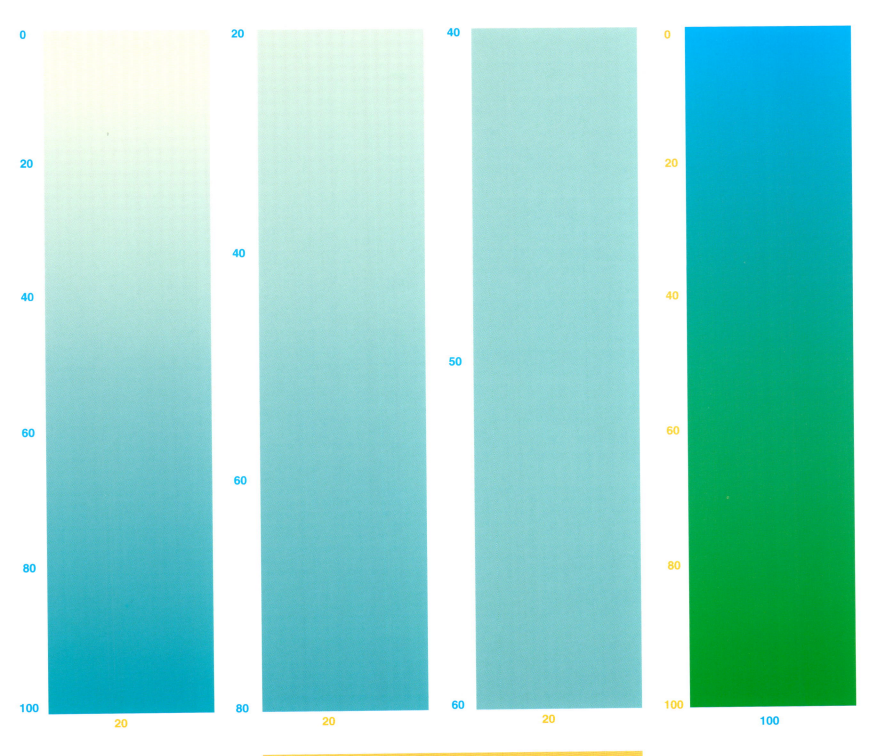

67

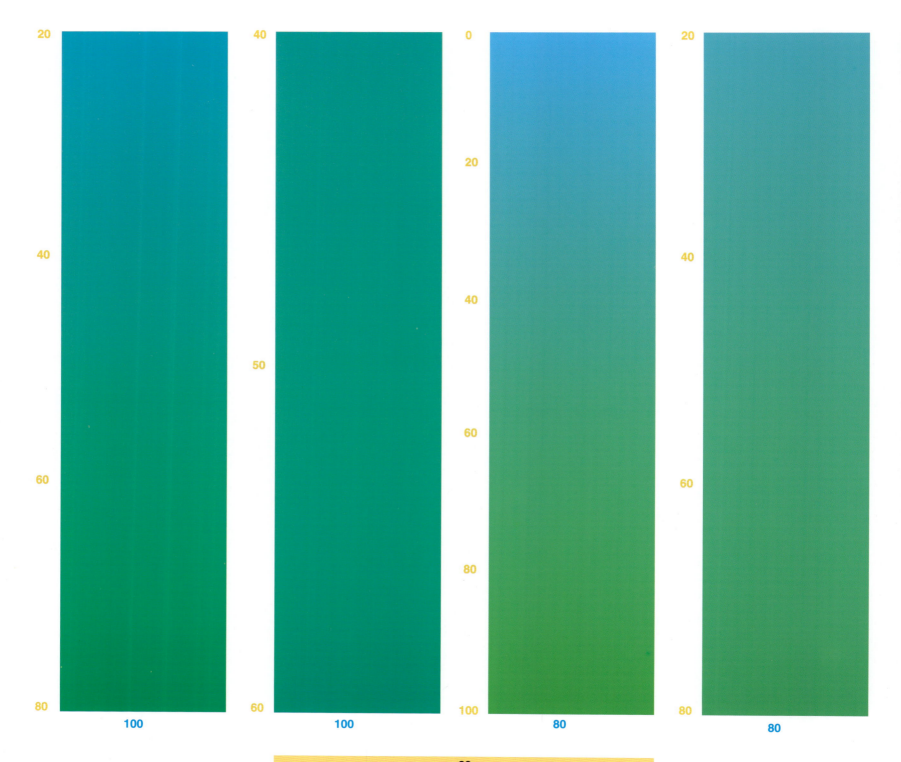

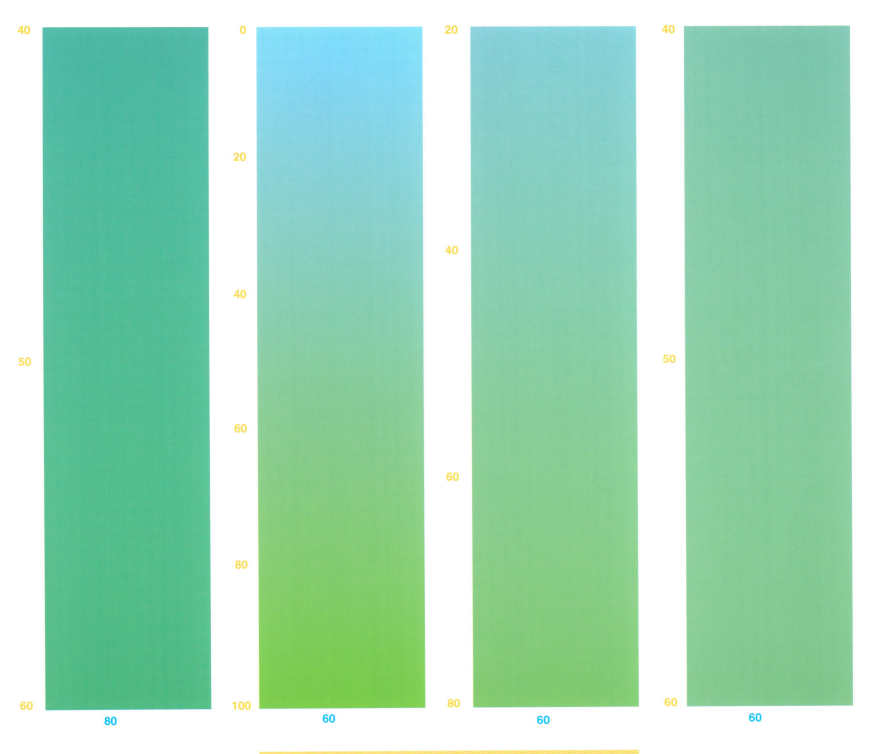

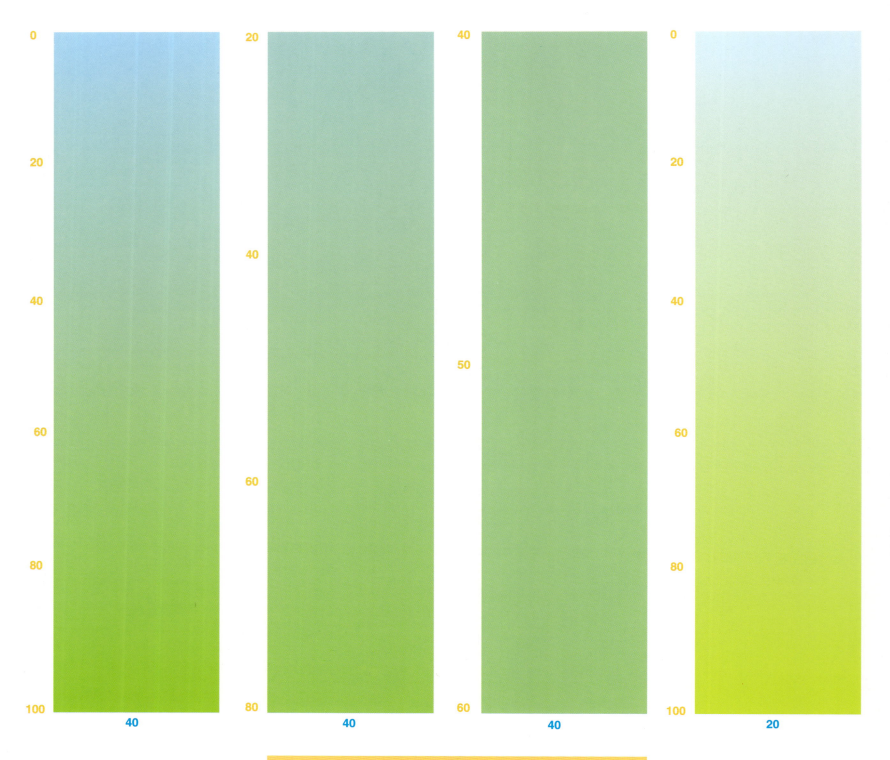

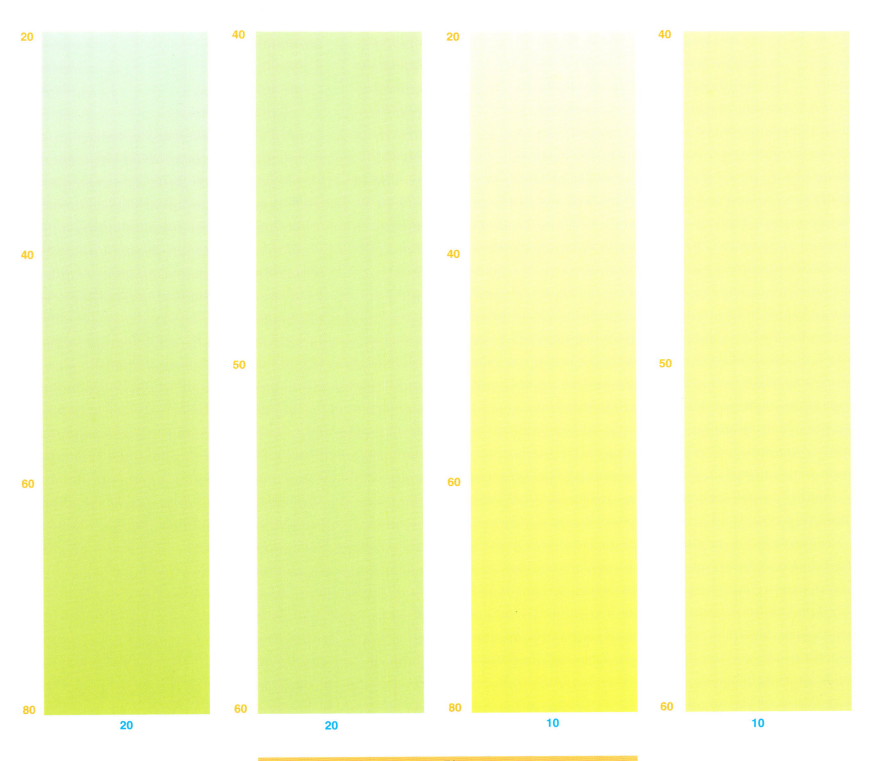

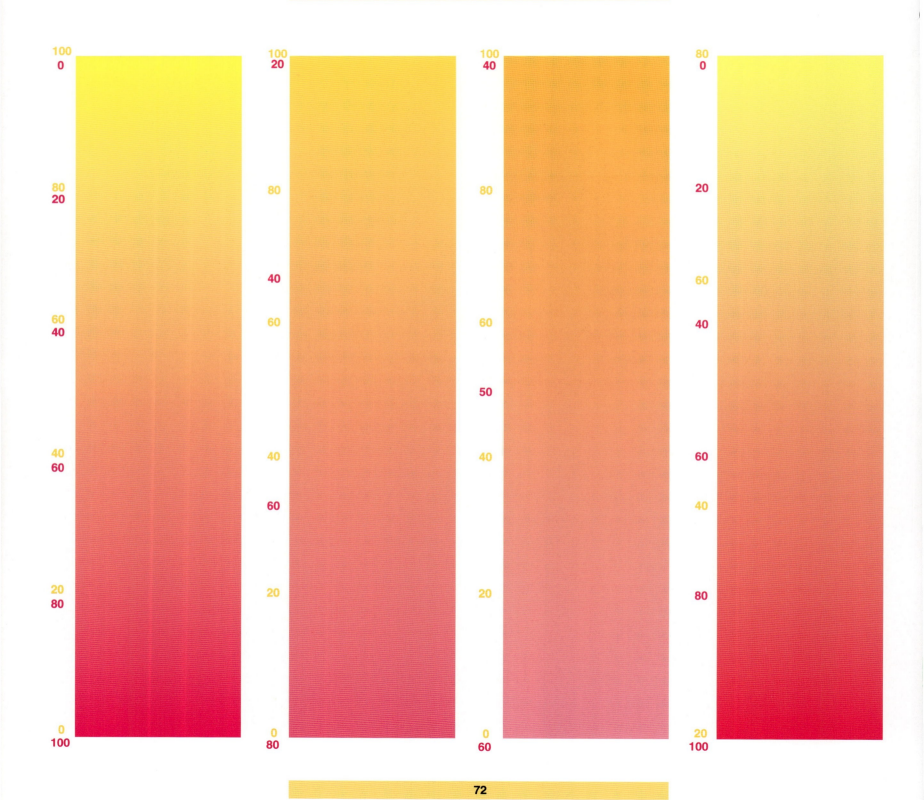

# TYPE & COLOR 2 - *BLENDS*

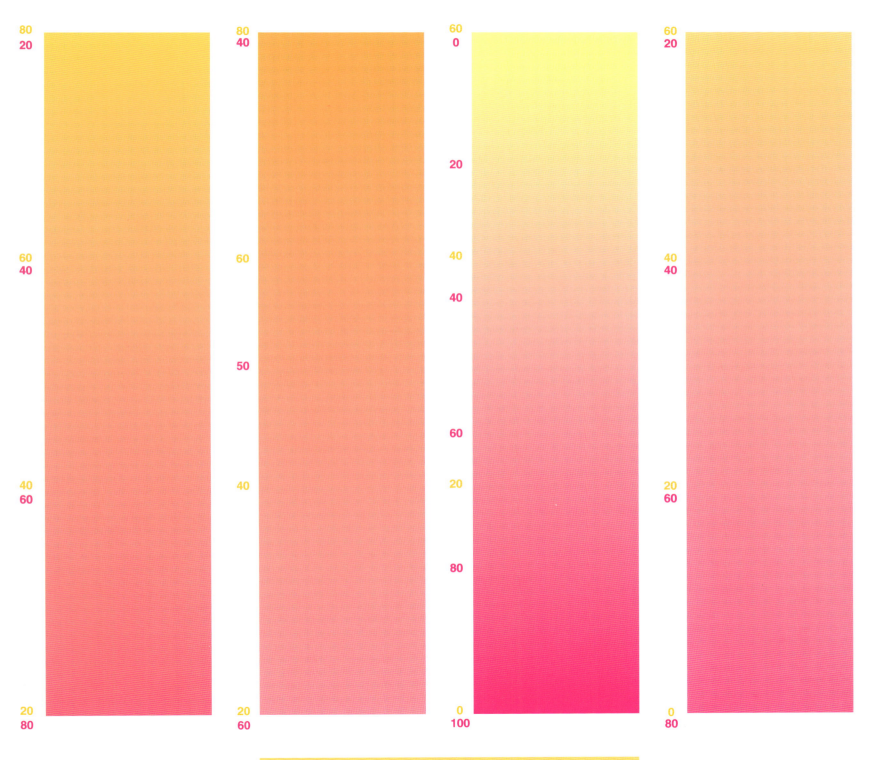

73

# TYPE & COLOR 2 - BLENDS

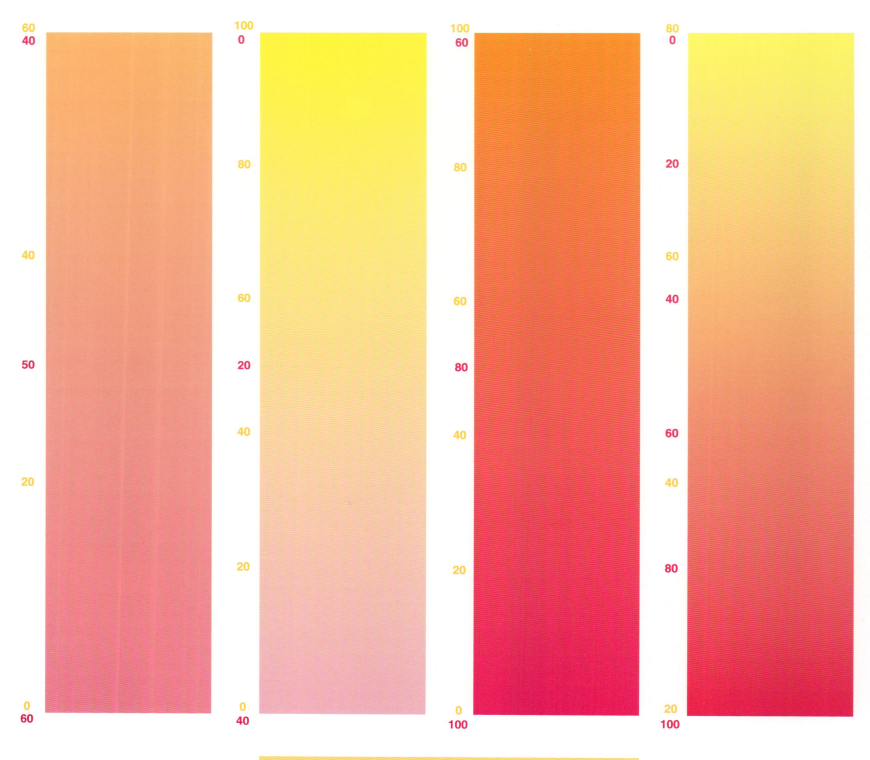

74

# TYPE & COLOR 2 - *BLENDS*

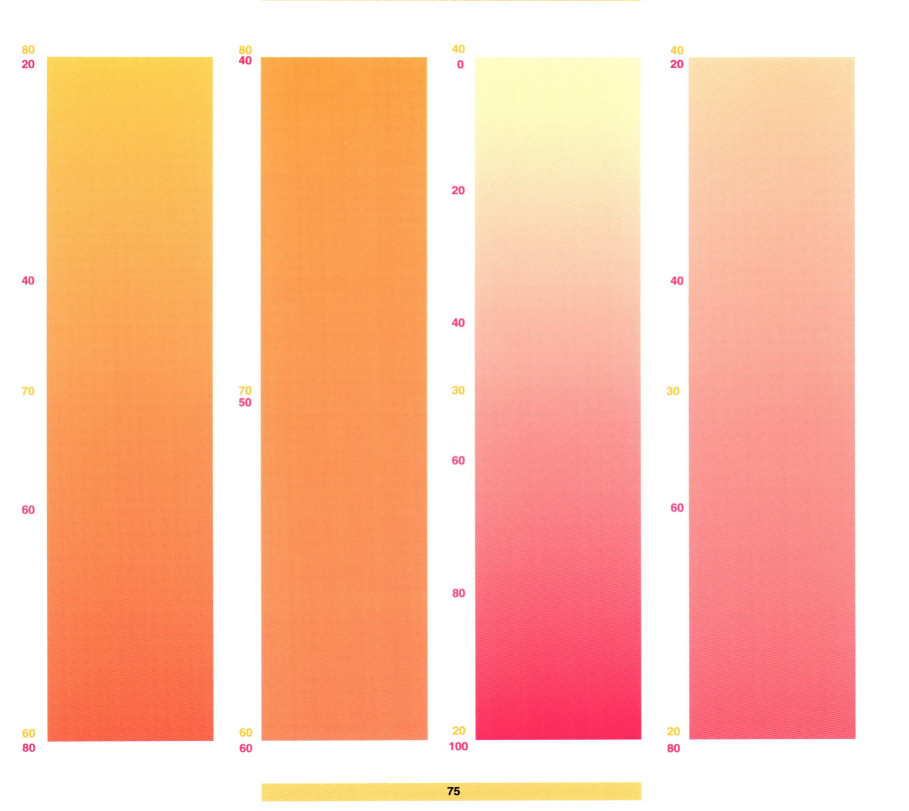

75

# TYPE & COLOR 2 - *BLENDS*

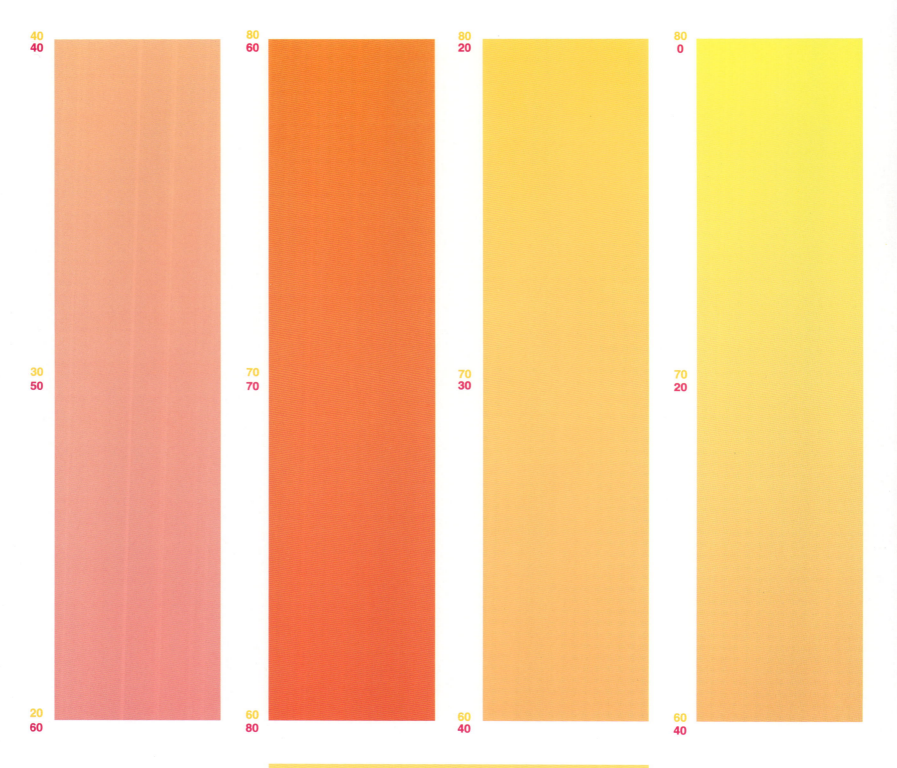

76

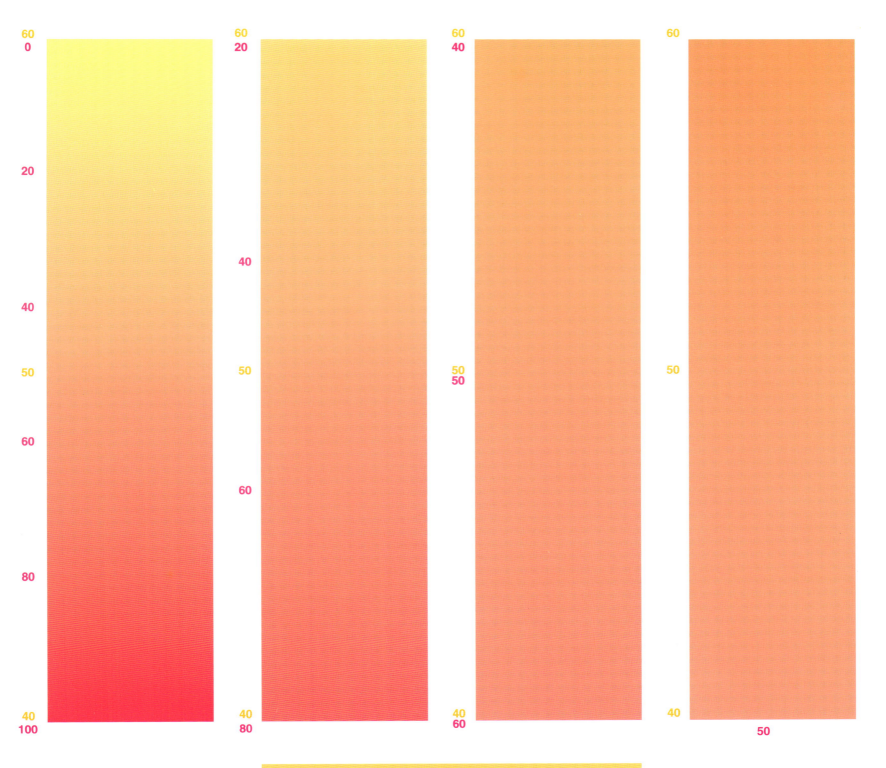

# TYPE & COLOR 2 - *BLENDS*

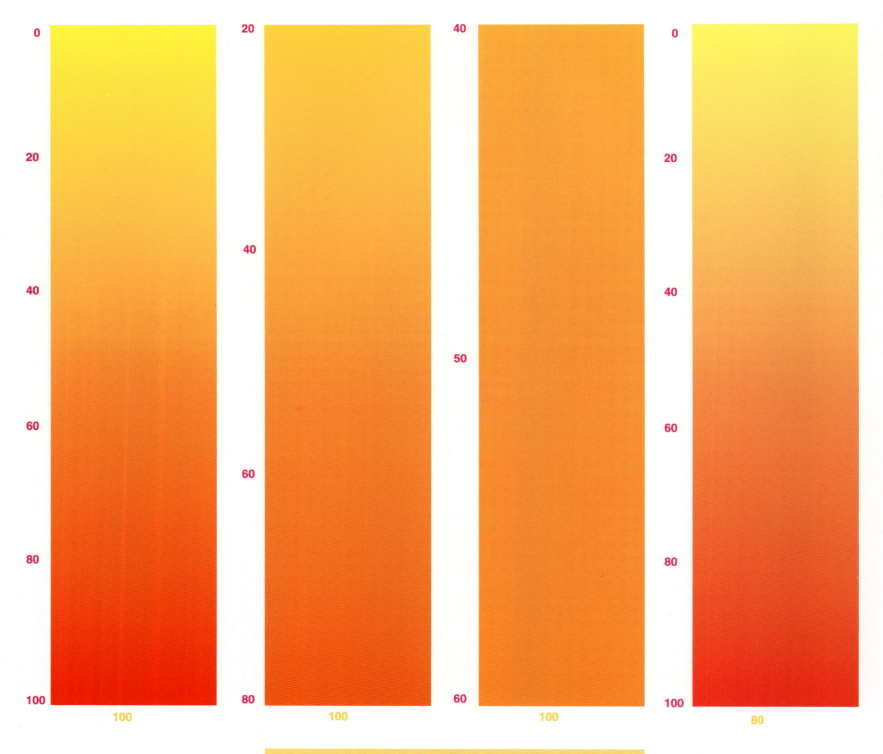

78

# TYPE & COLOR 2 - *BLENDS*

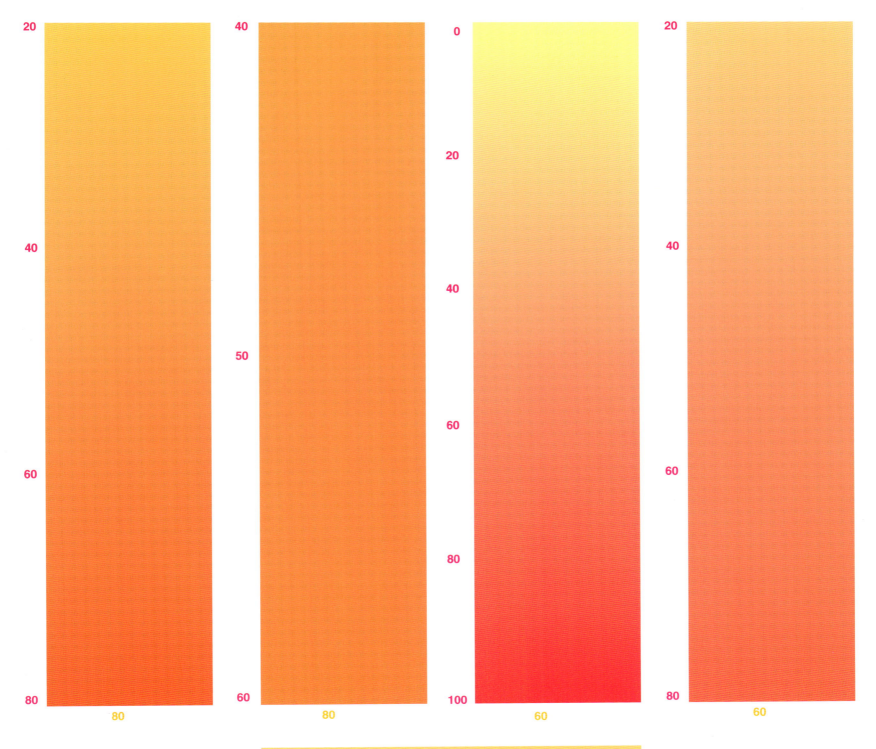

**TYPE & COLOR 2 - *BLENDS***

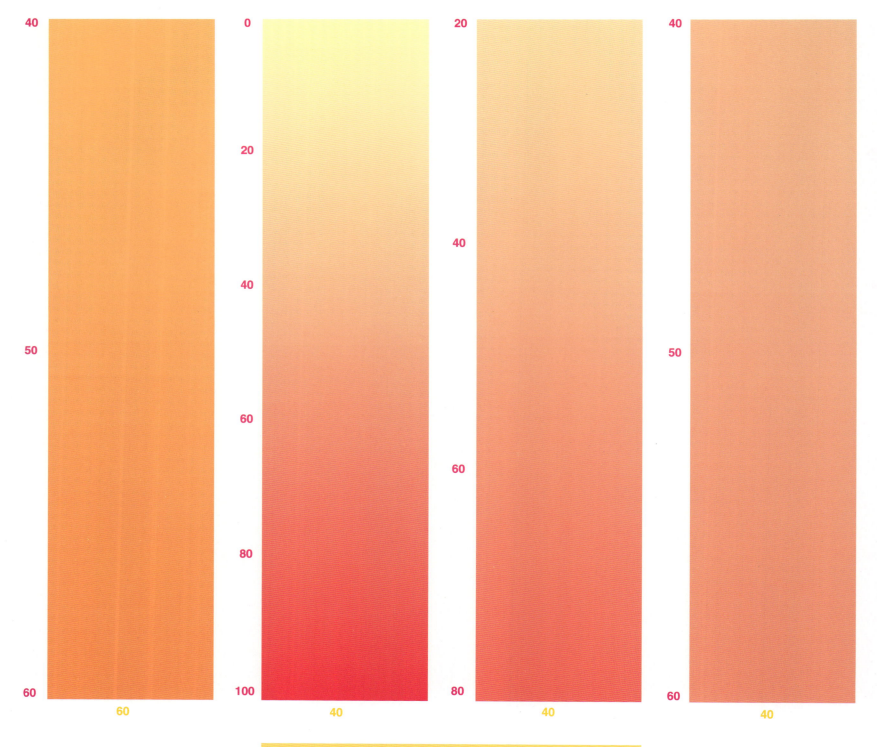

**80**

# TYPE & COLOR 2 - BLENDS

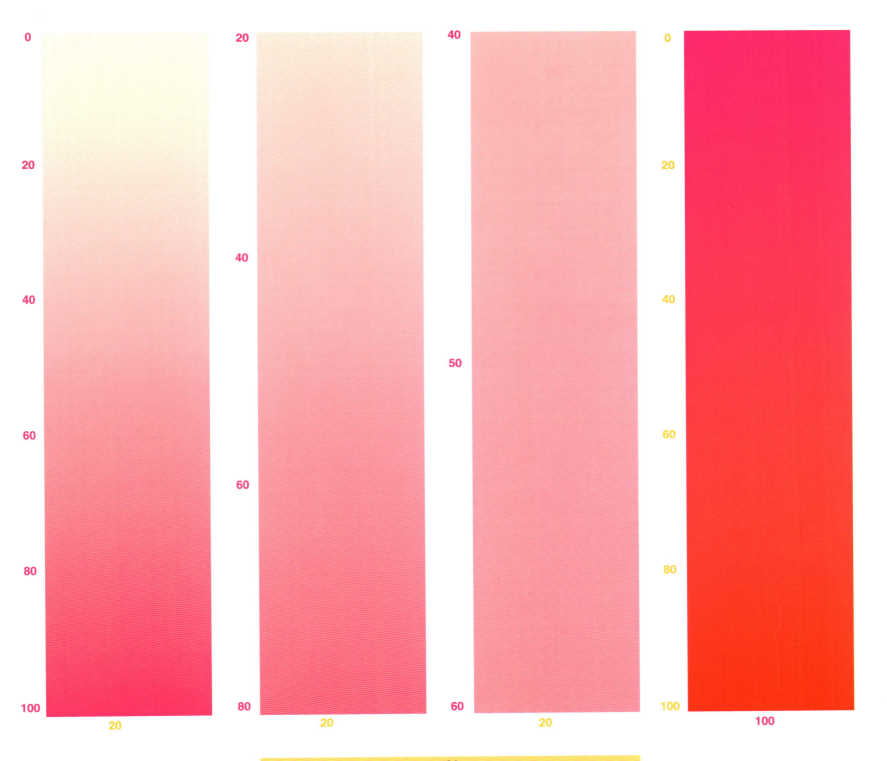

81

# TYPE & COLOR 2 - *BLENDS*

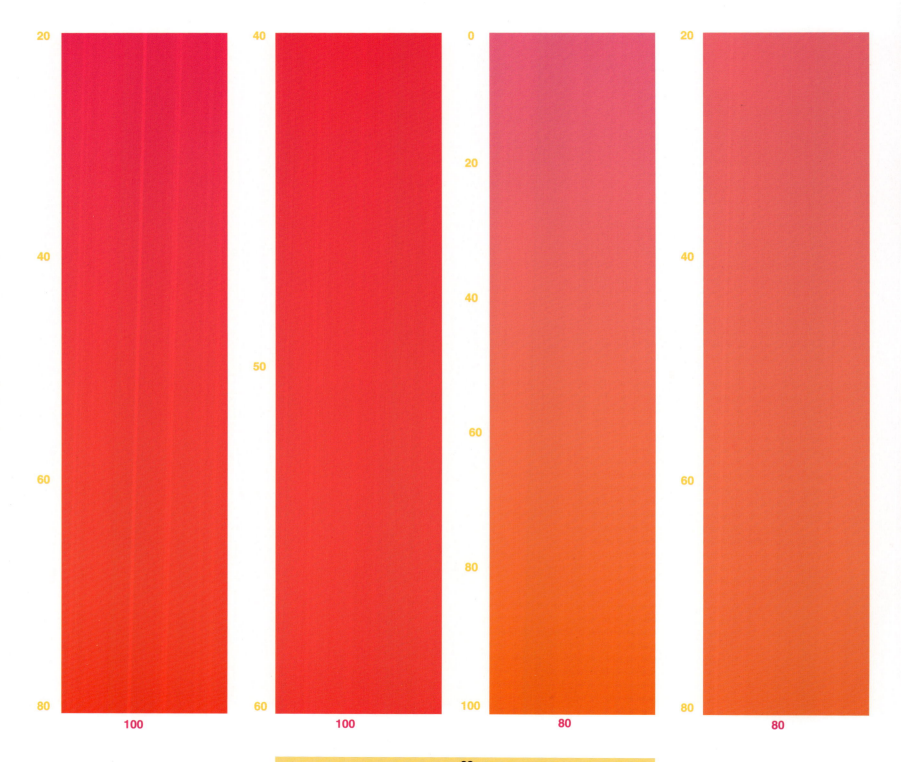

82

# TYPE & COLOR 2 - *BLENDS*

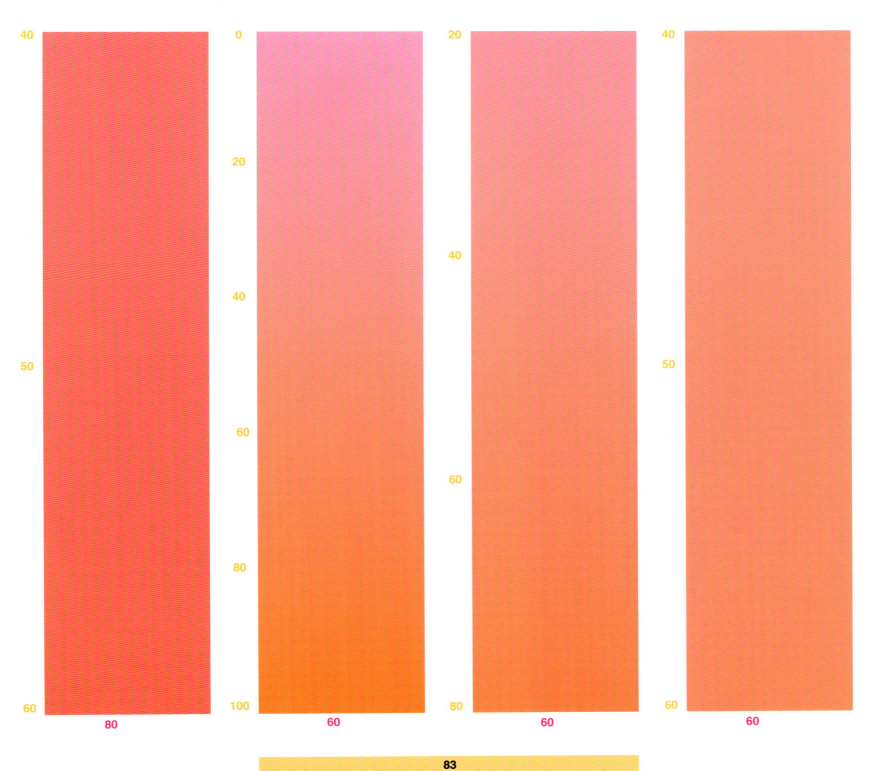

83

# TYPE & COLOR 2 - *BLENDS*

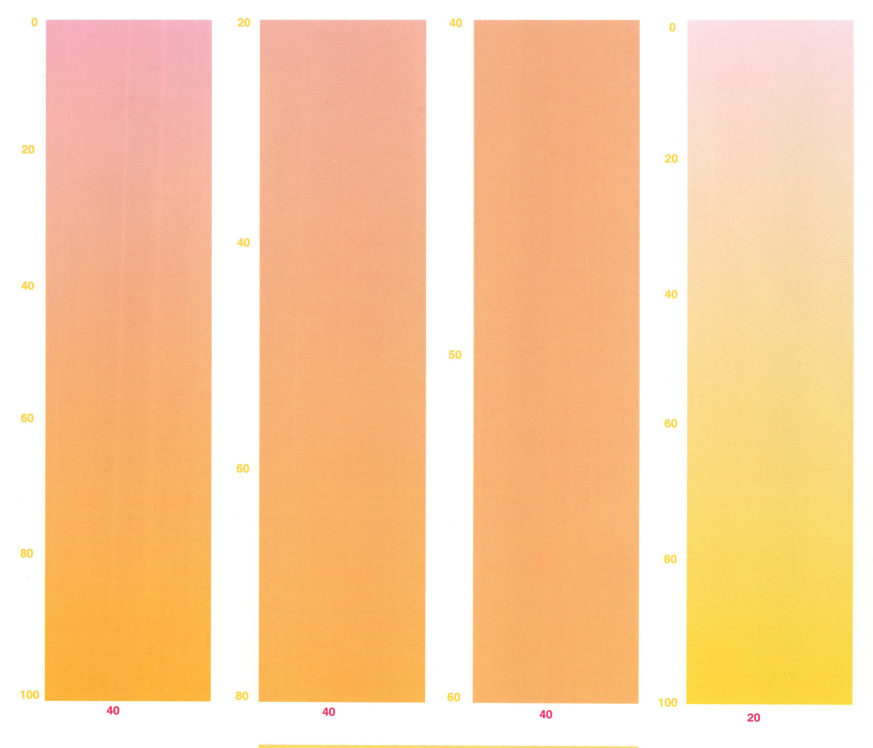

84

# TYPE & COLOR 2 - *BLENDS*

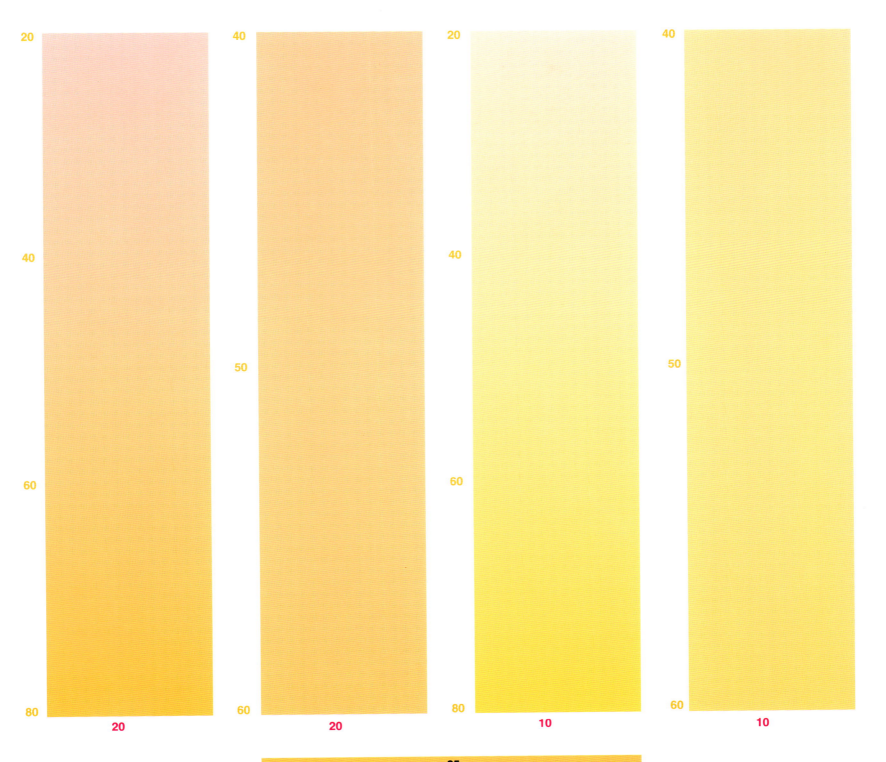

85

# TYPE & COLOR 2 - *BLENDS*

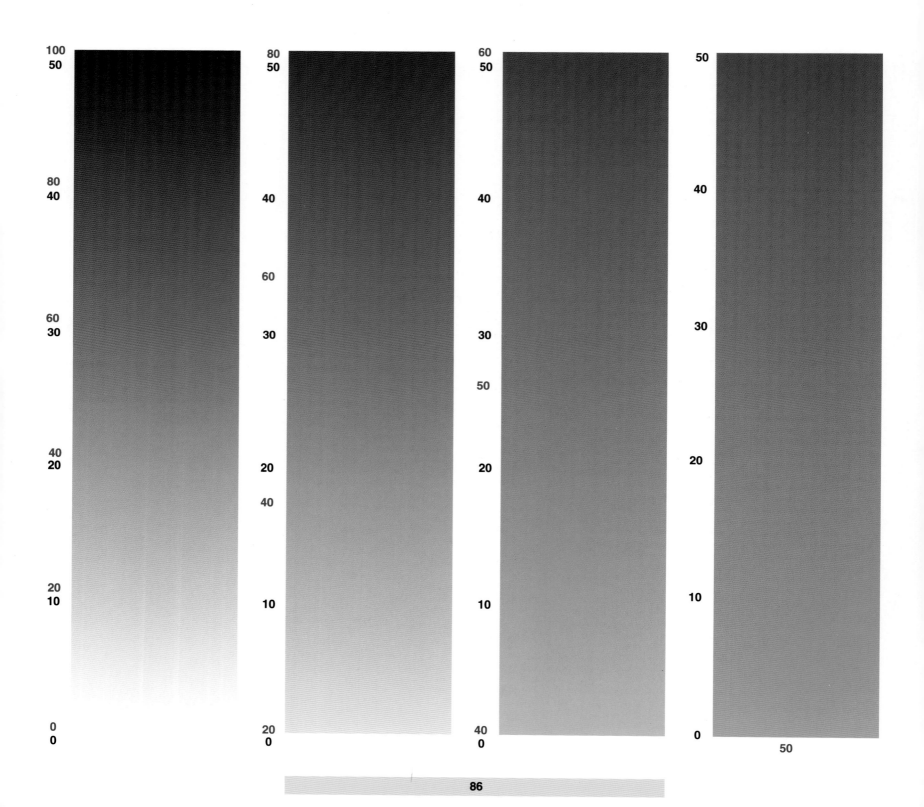

**TYPE & COLOR 2 - *BLENDS***

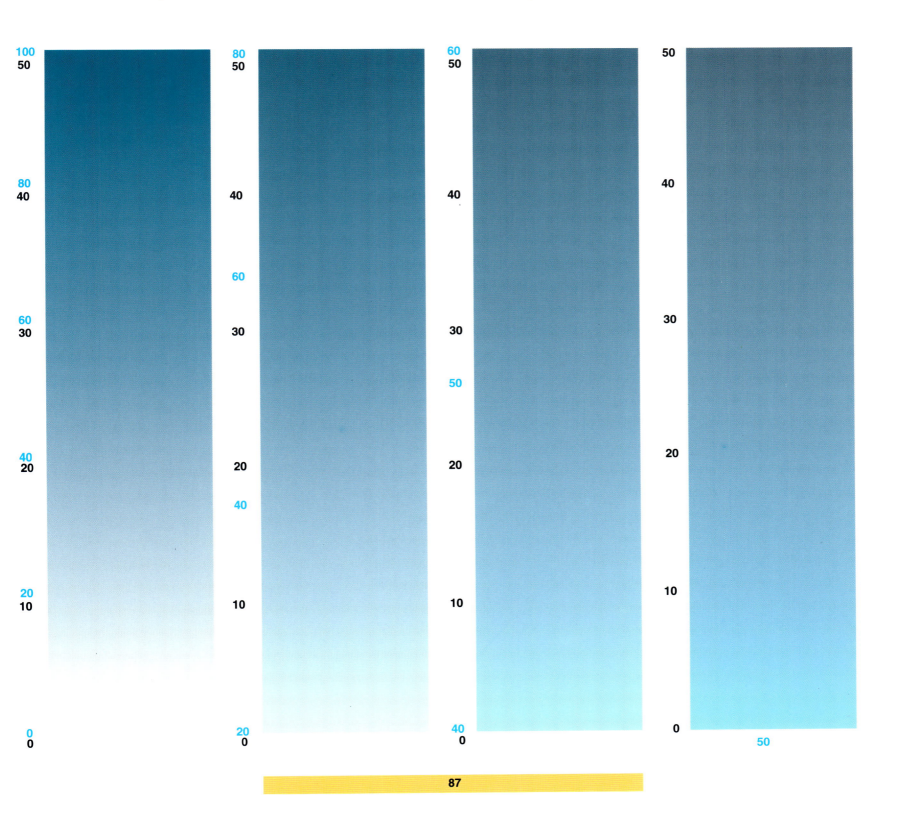

87

**TYPE & COLOR 2 - *BLENDS***

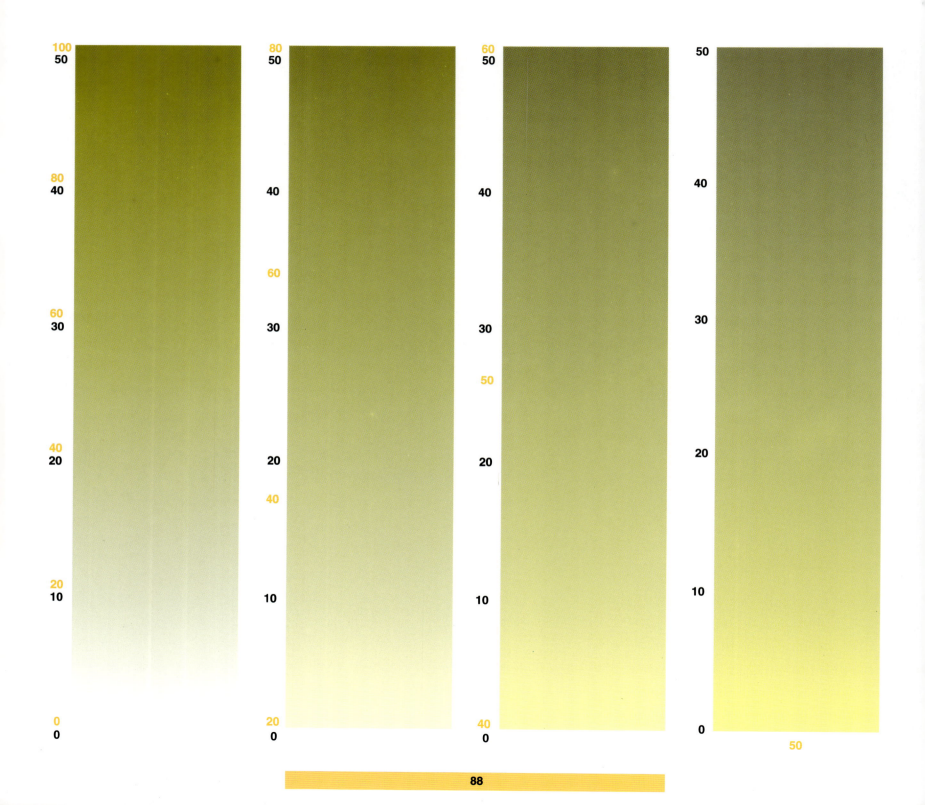

88

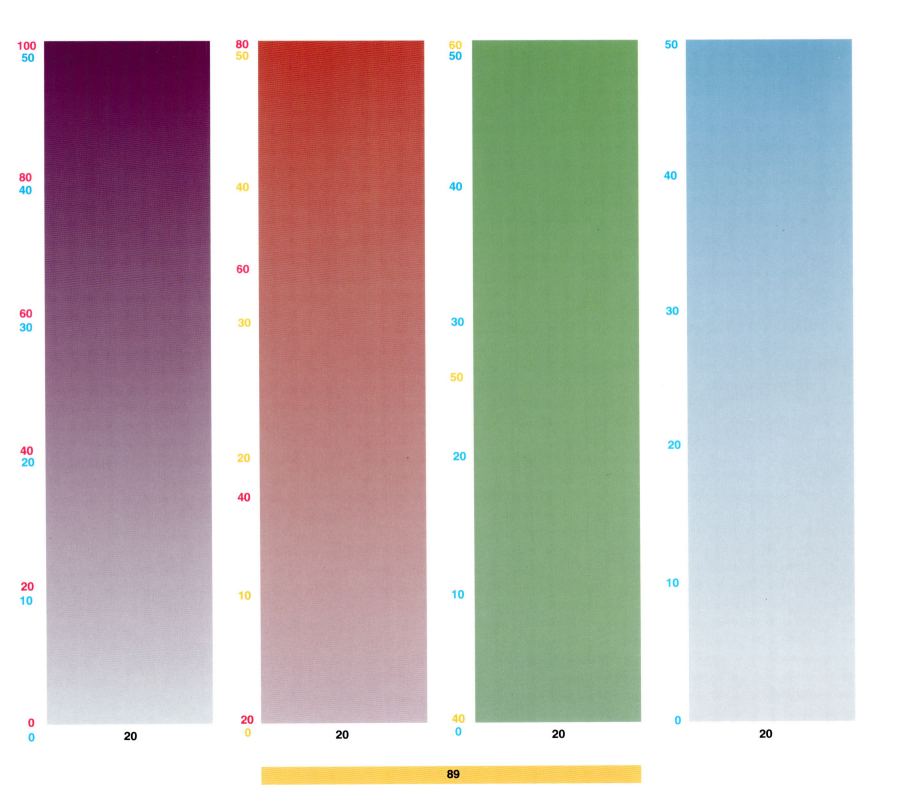

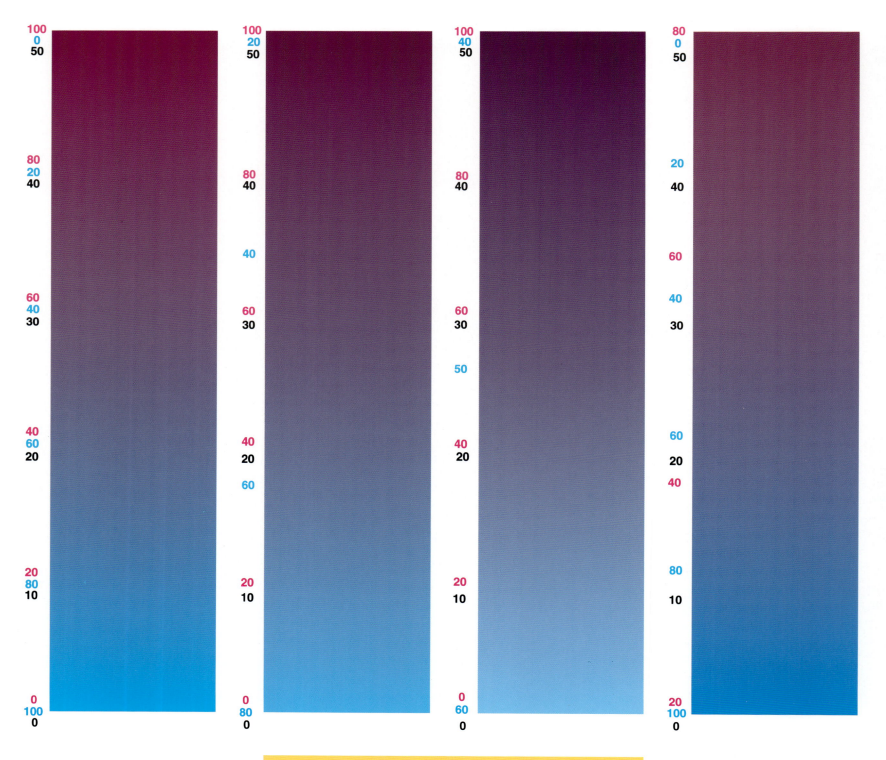

**TYPE & COLOR 2 - *BLENDS***

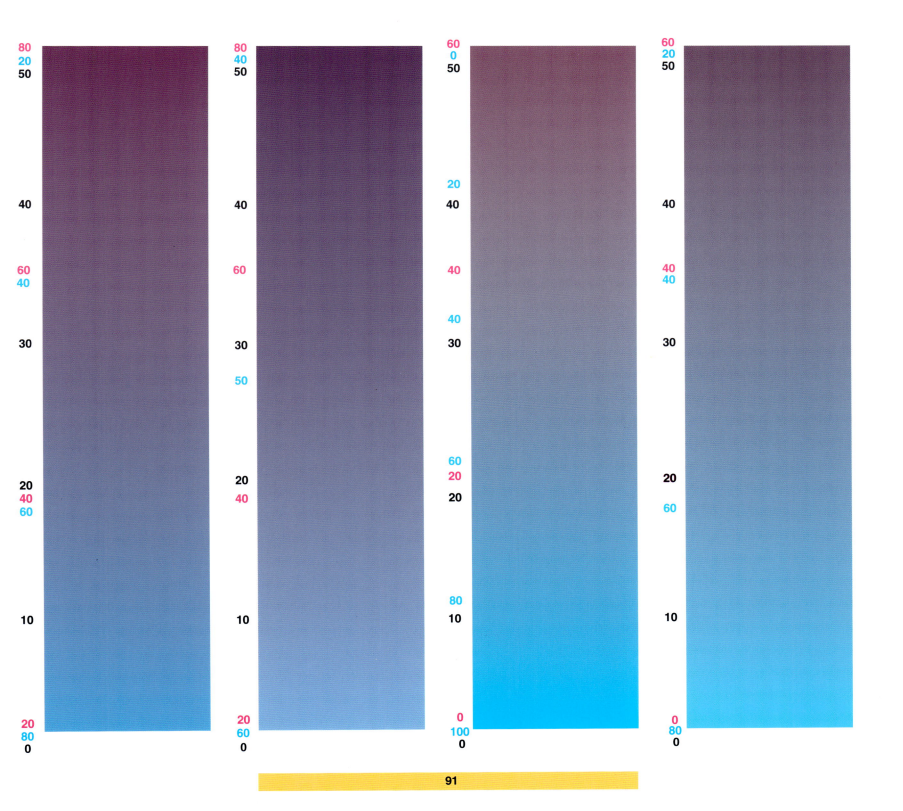

91

**TYPE & COLOR 2 - *BLENDS***

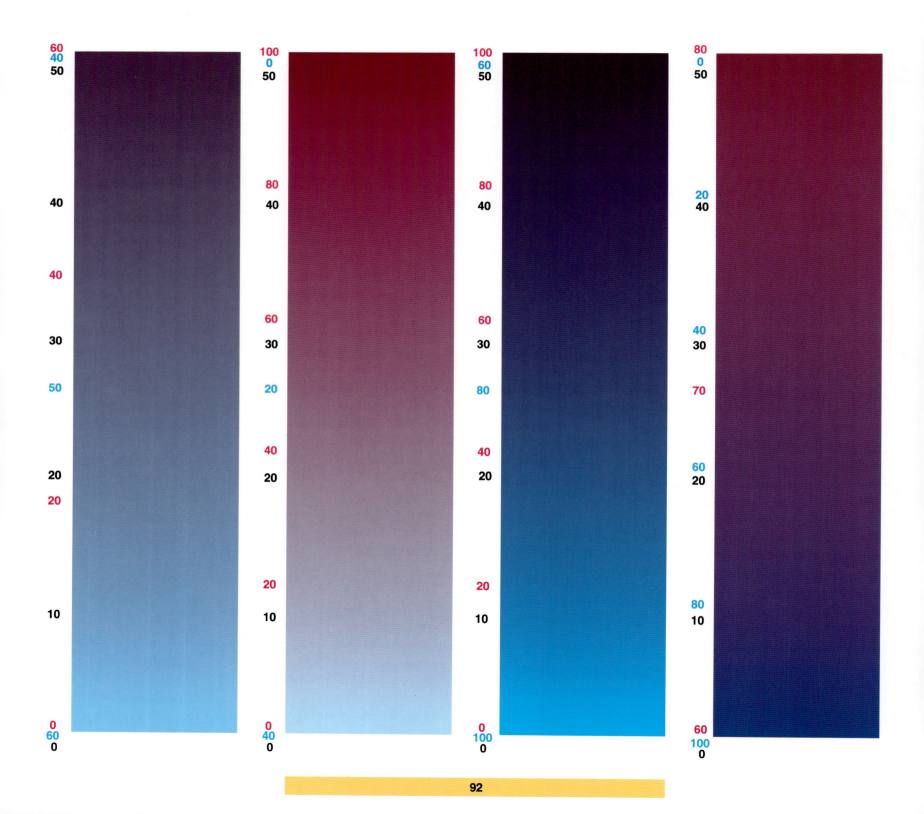

92

# TYPE & COLOR 2 - *BLENDS*

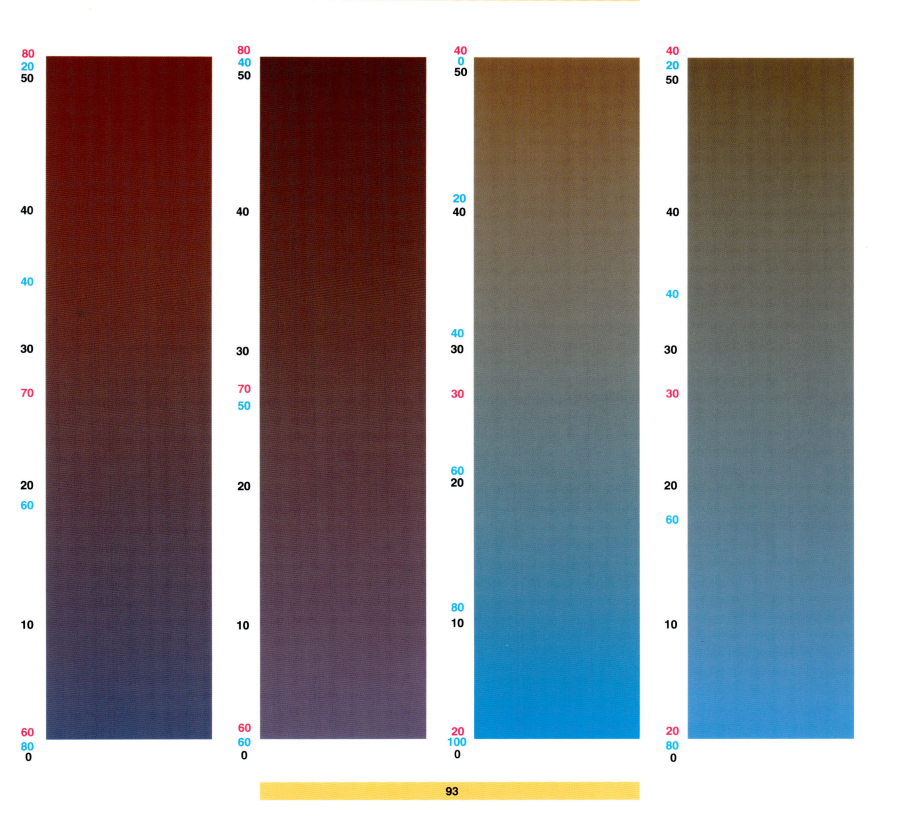

93

**TYPE & COLOR 2 - *BLENDS***

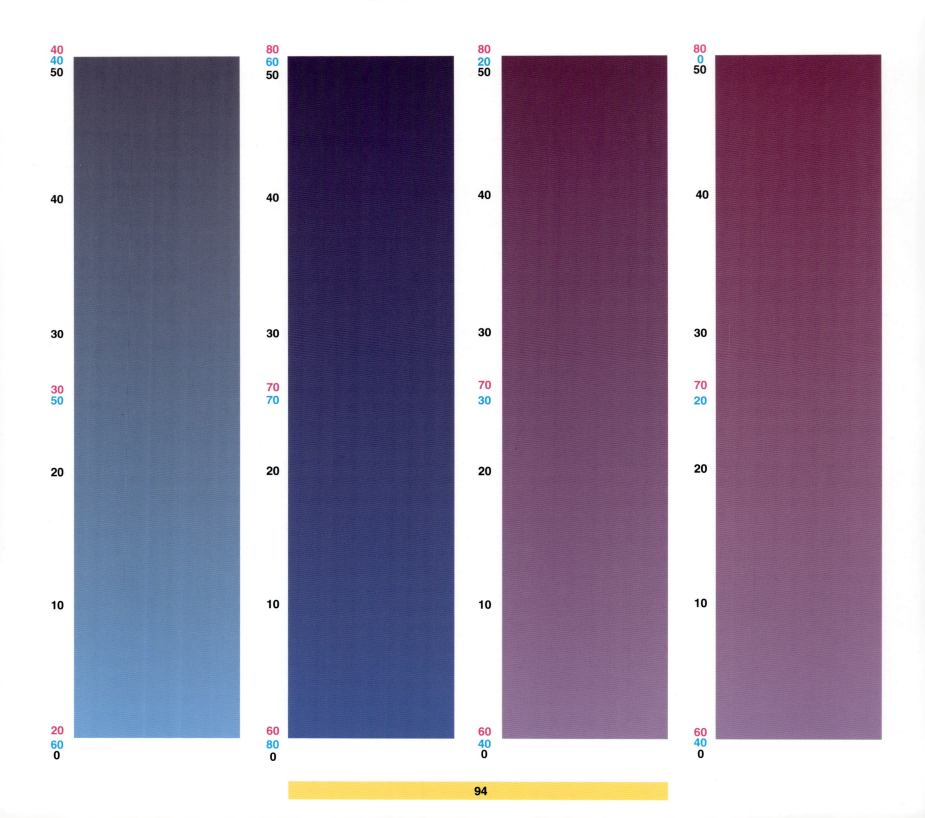

94

**TYPE & COLOR 2 - *BLENDS***

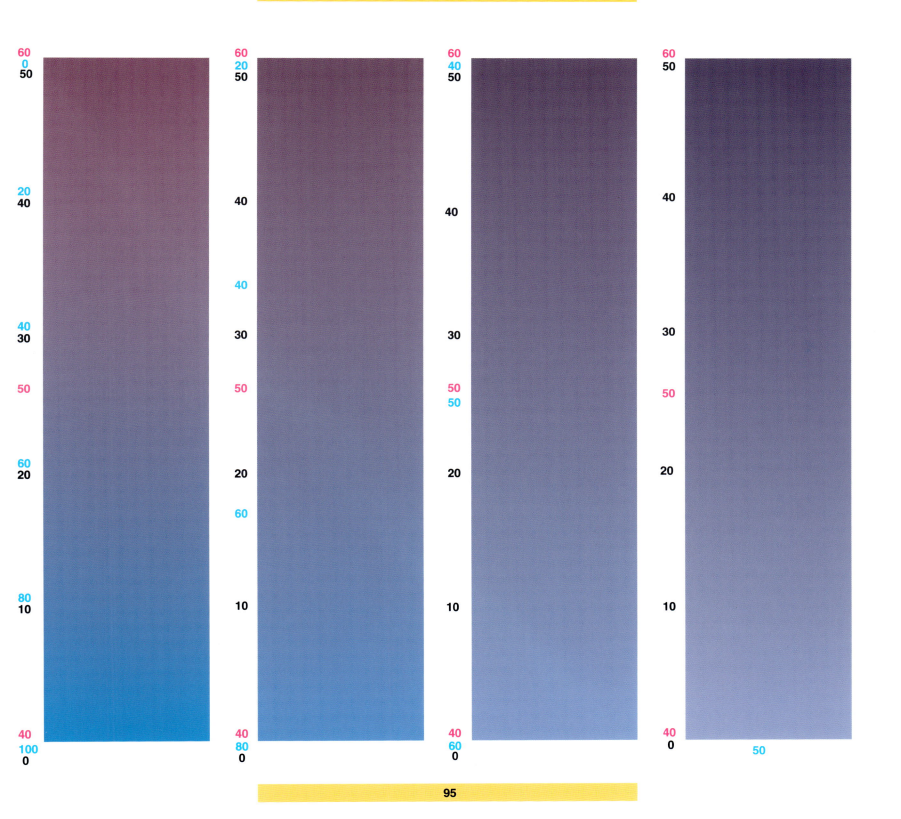

95

**TYPE & COLOR 2 -** *BLENDS*

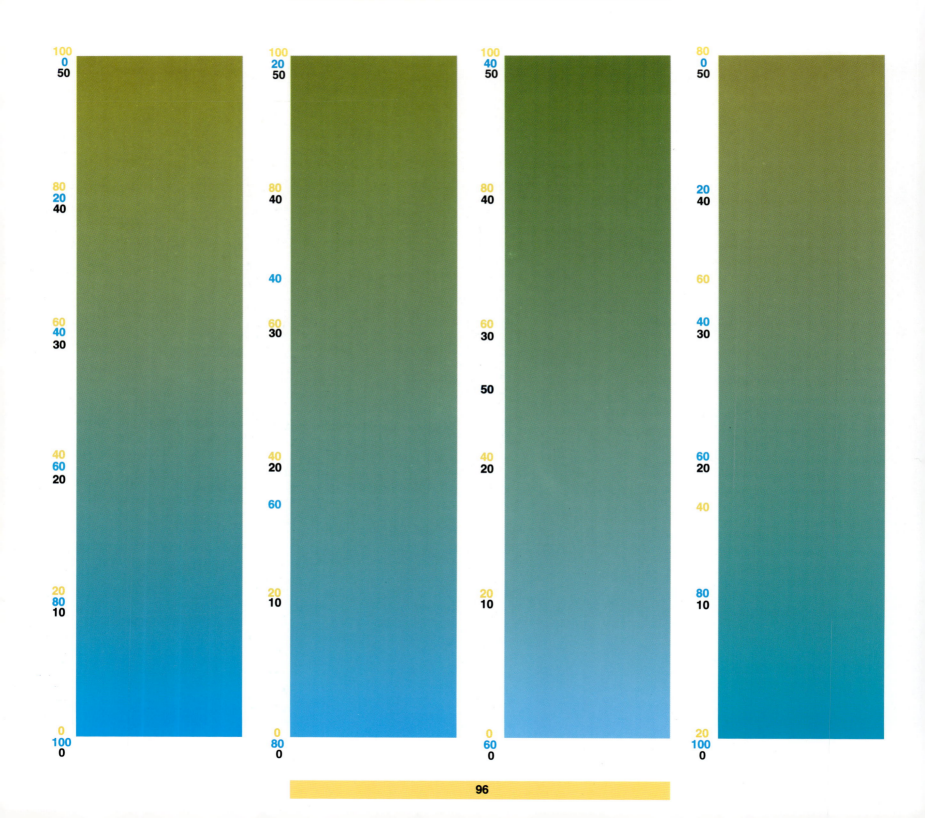

# TYPE & COLOR 2 - *BLENDS*

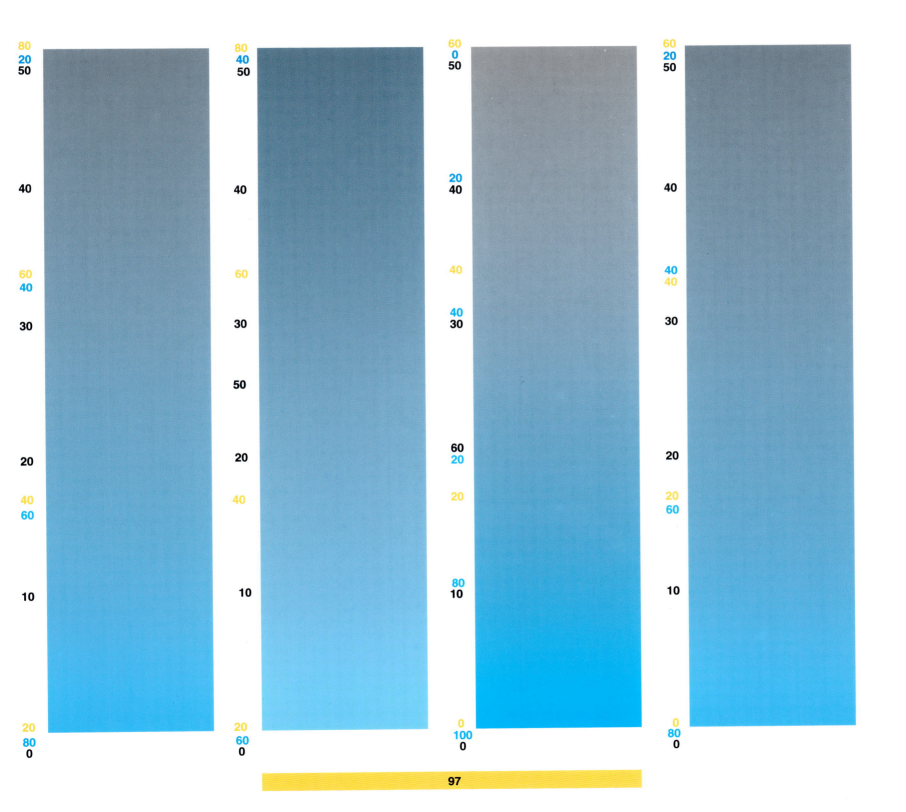

97

# TYPE & COLOR 2 - *BLENDS*

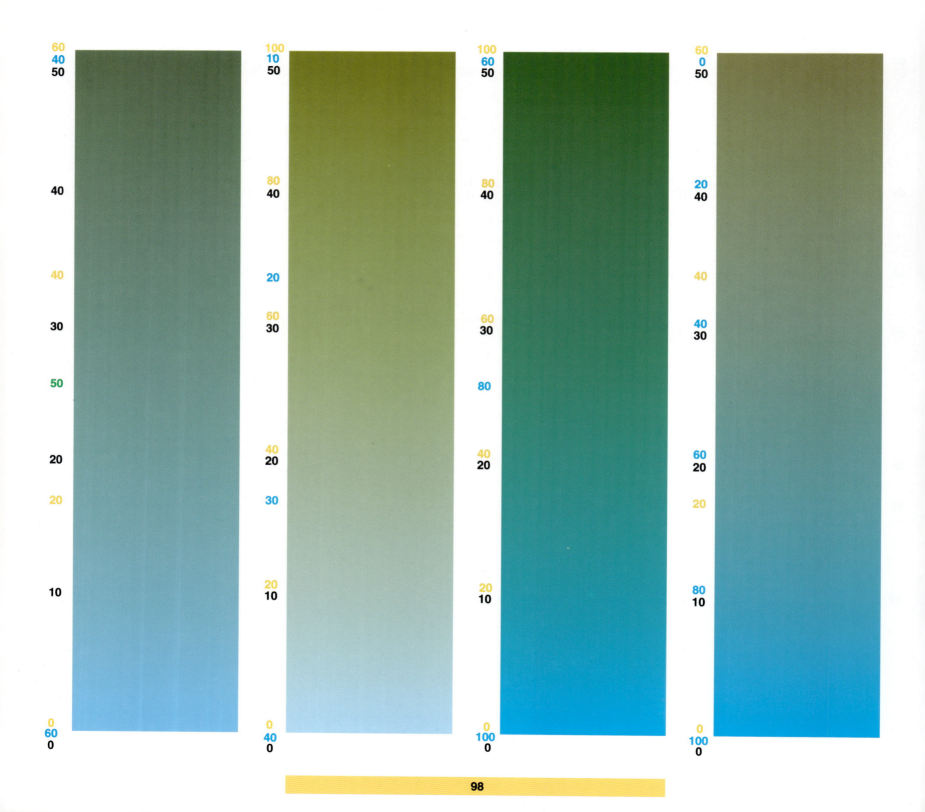

98

# TYPE & COLOR 2 - *BLENDS*

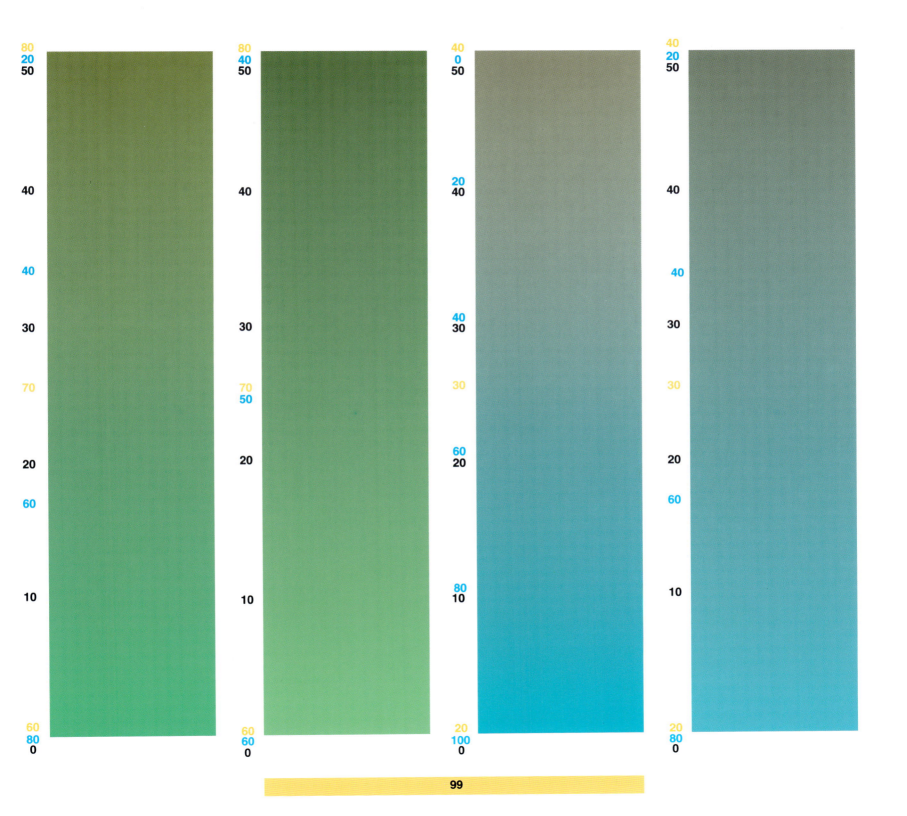

99

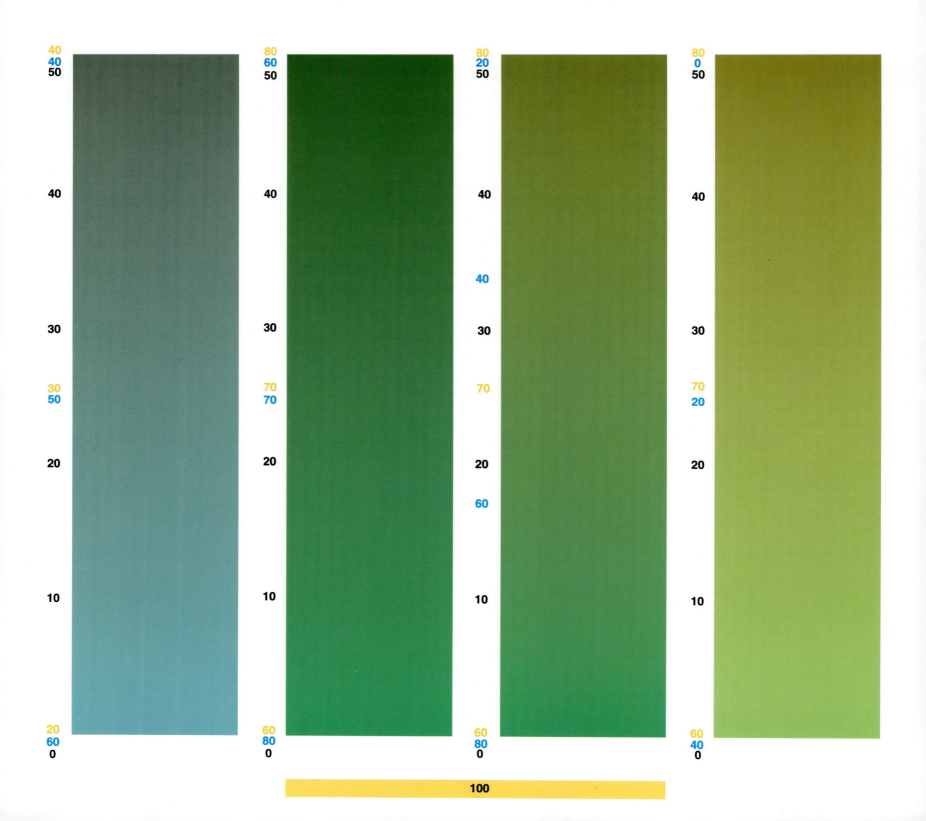

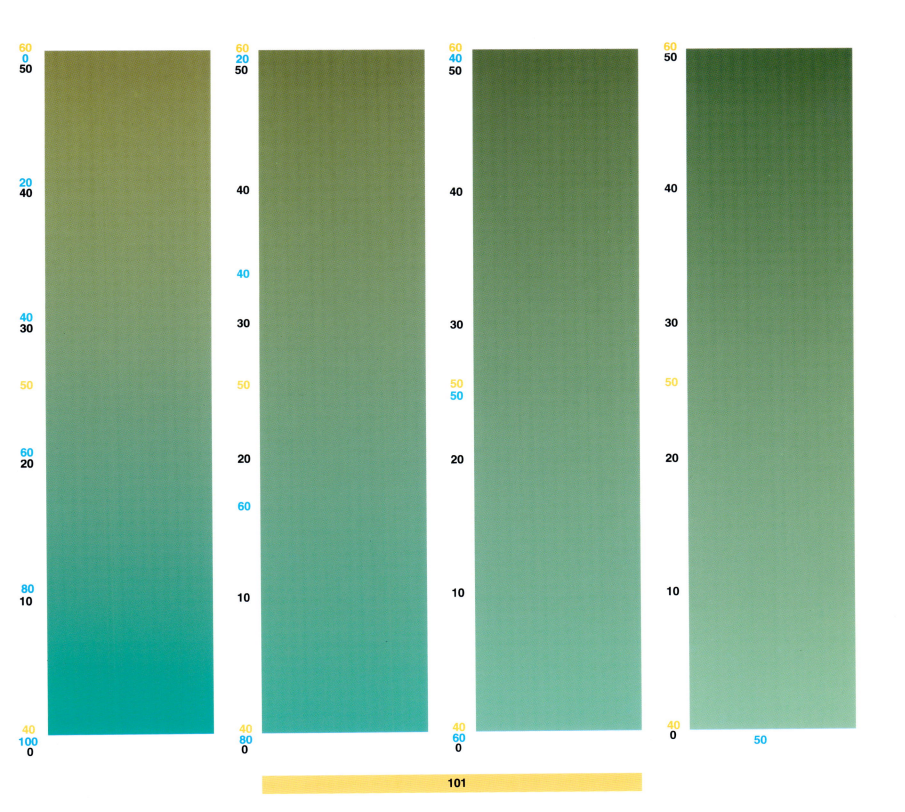

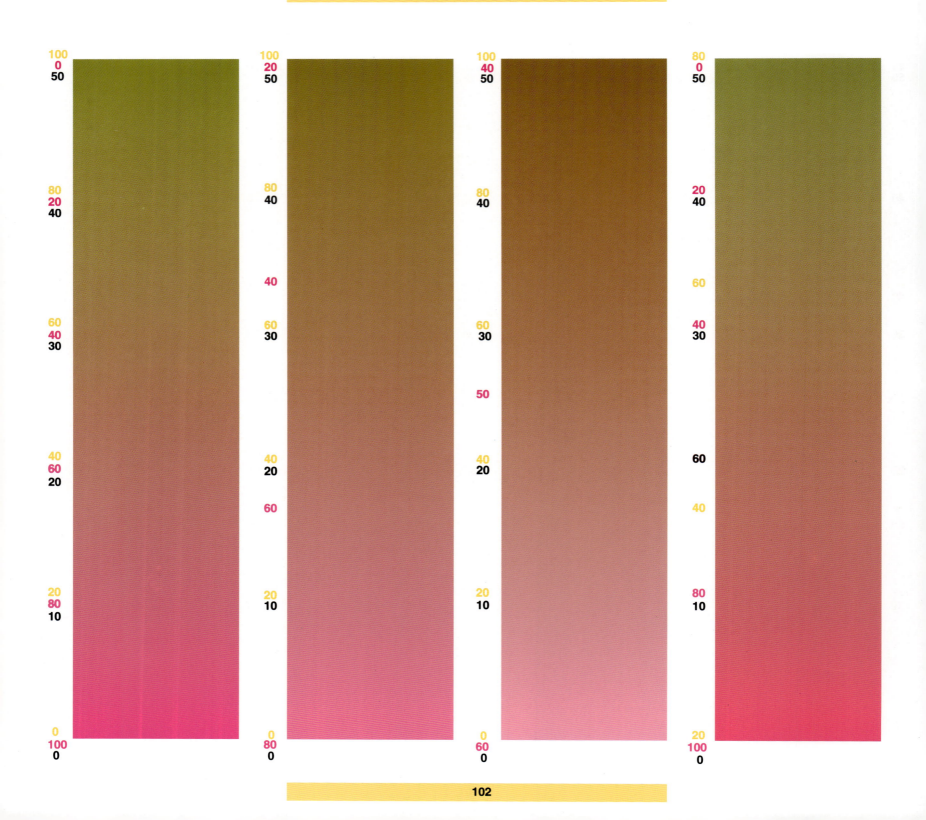

**TYPE & COLOR 2 - BLENDS**

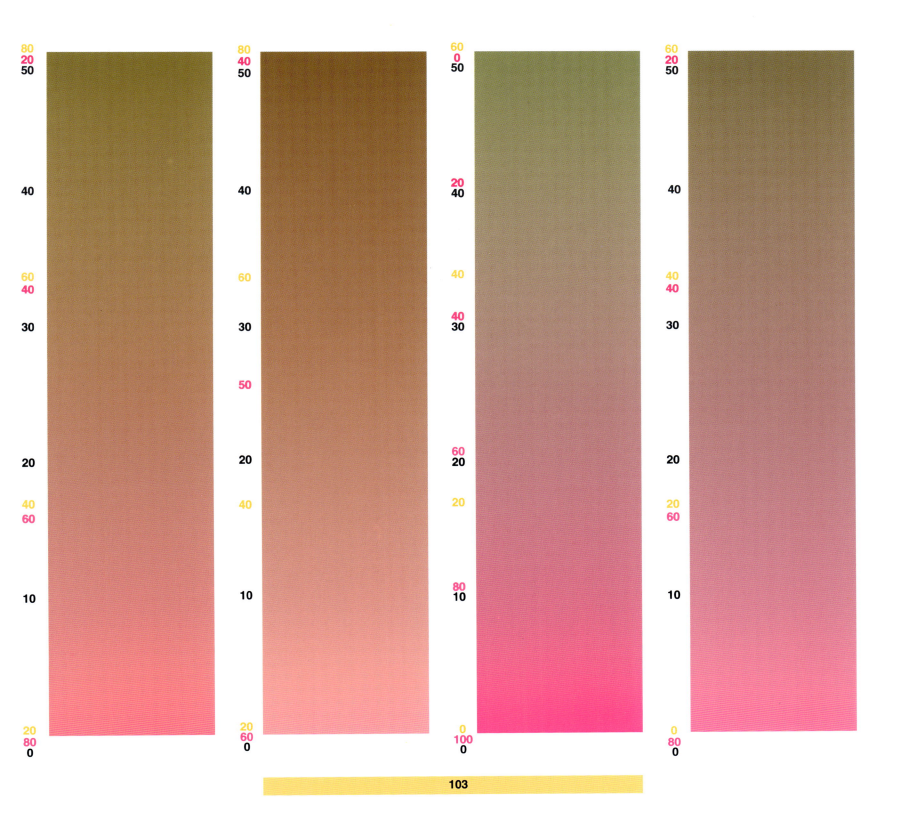

103

# TYPE & COLOR 2 - *BLENDS*

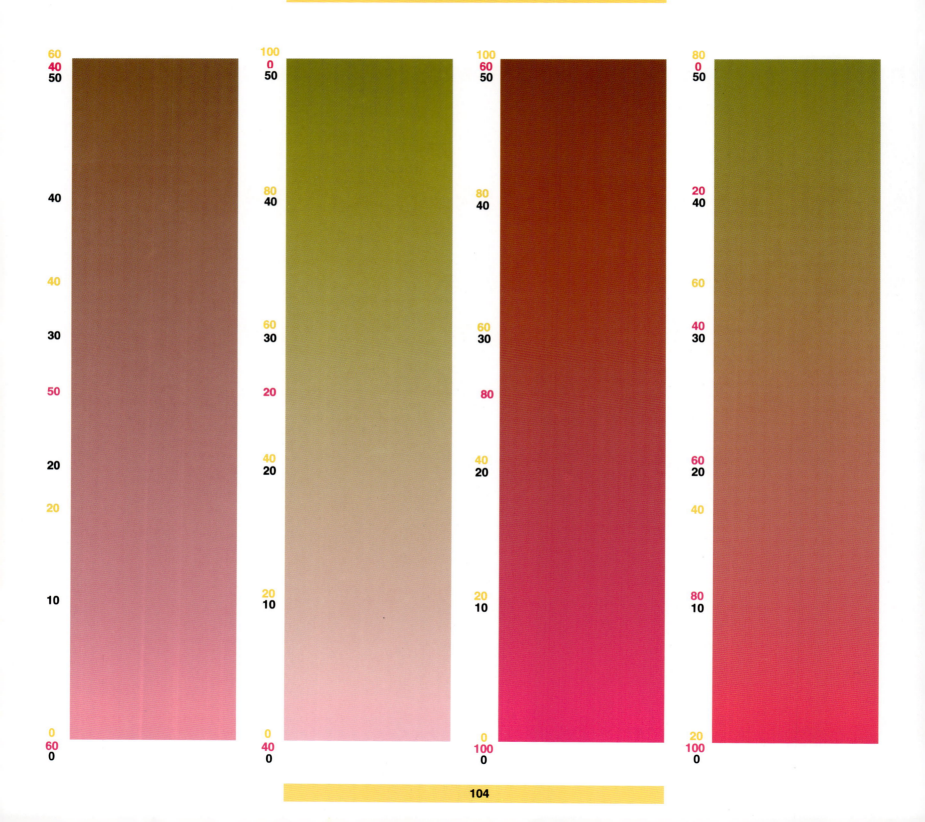

104

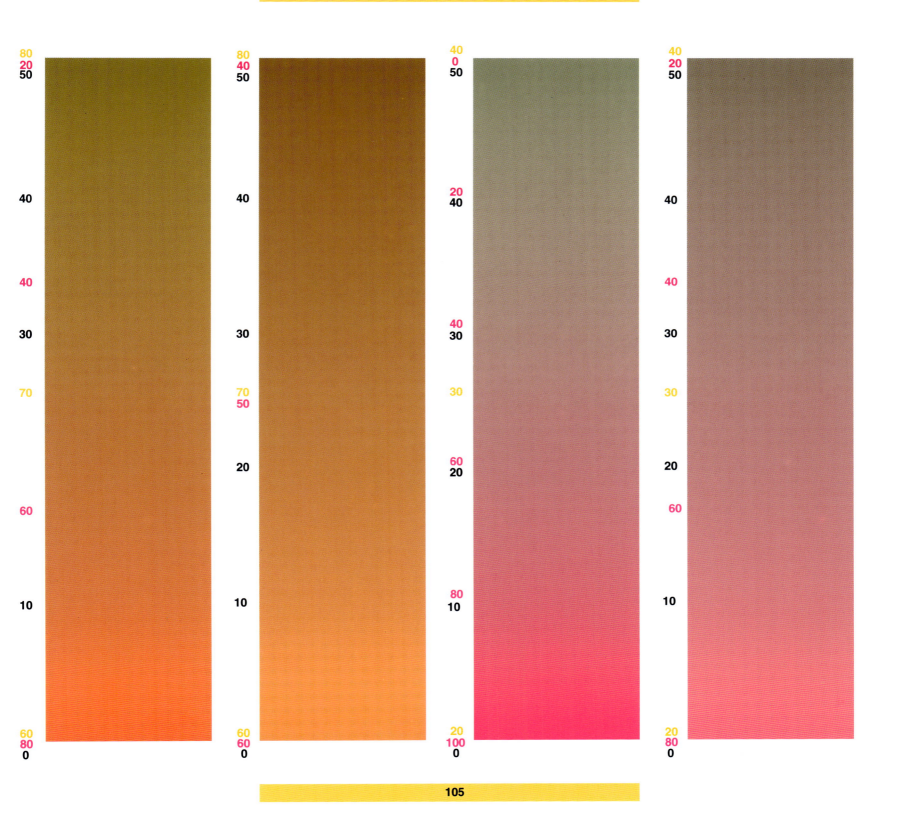

# TYPE & COLOR 2 - *BLENDS*

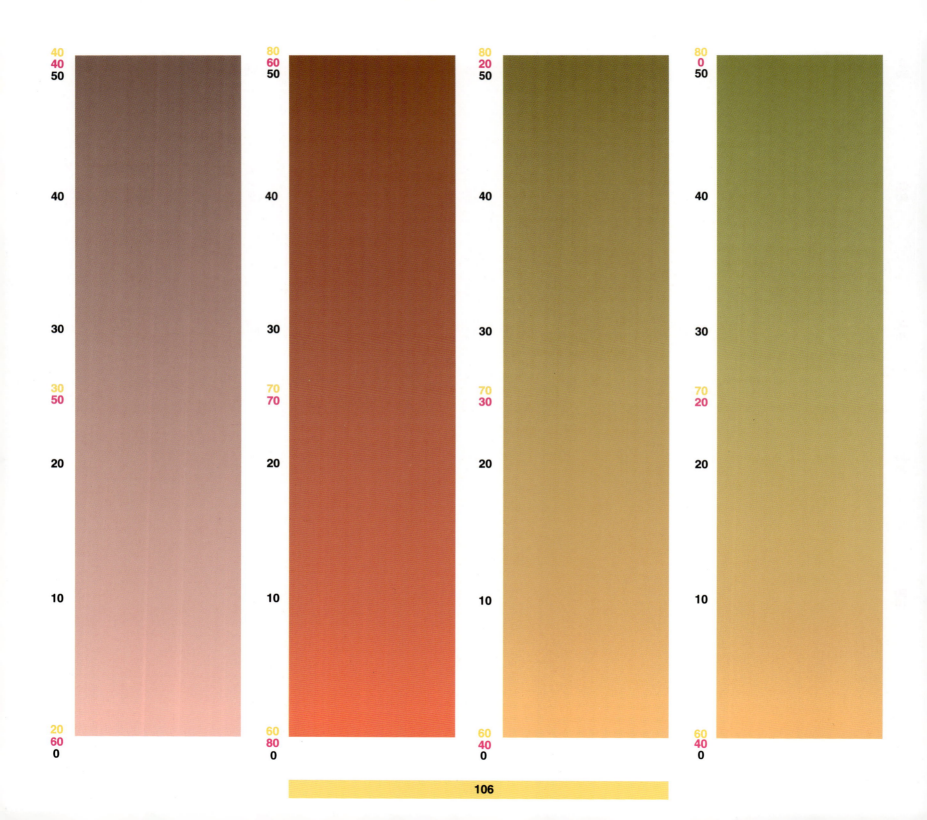

106

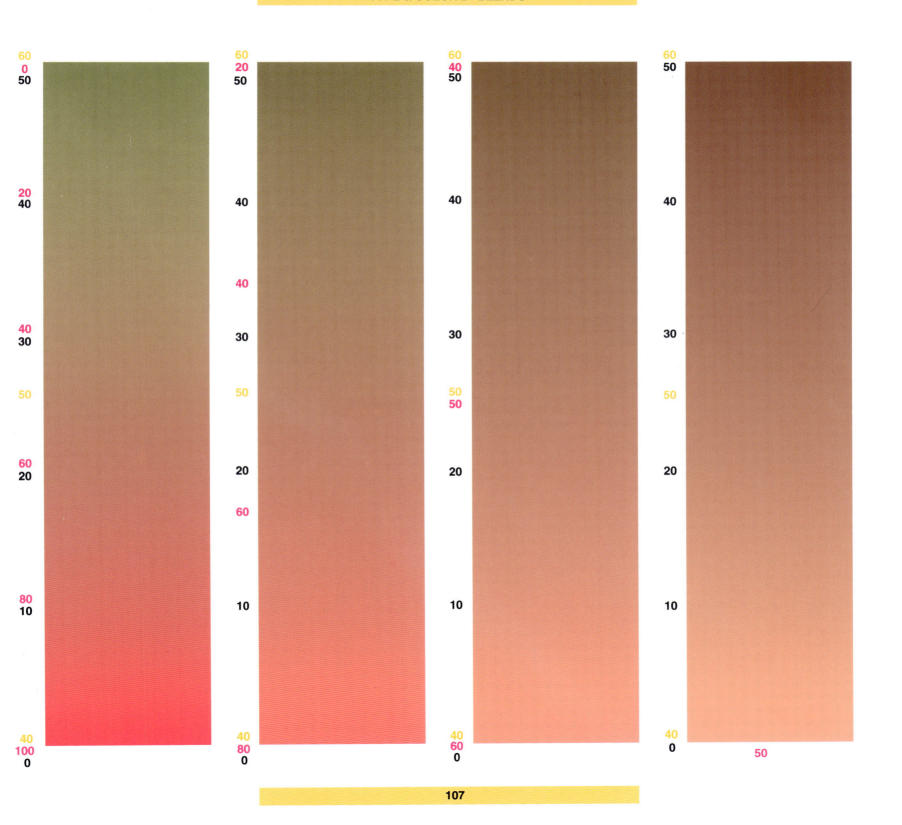

**TYPE & COLOR 2 - *BLENDS***

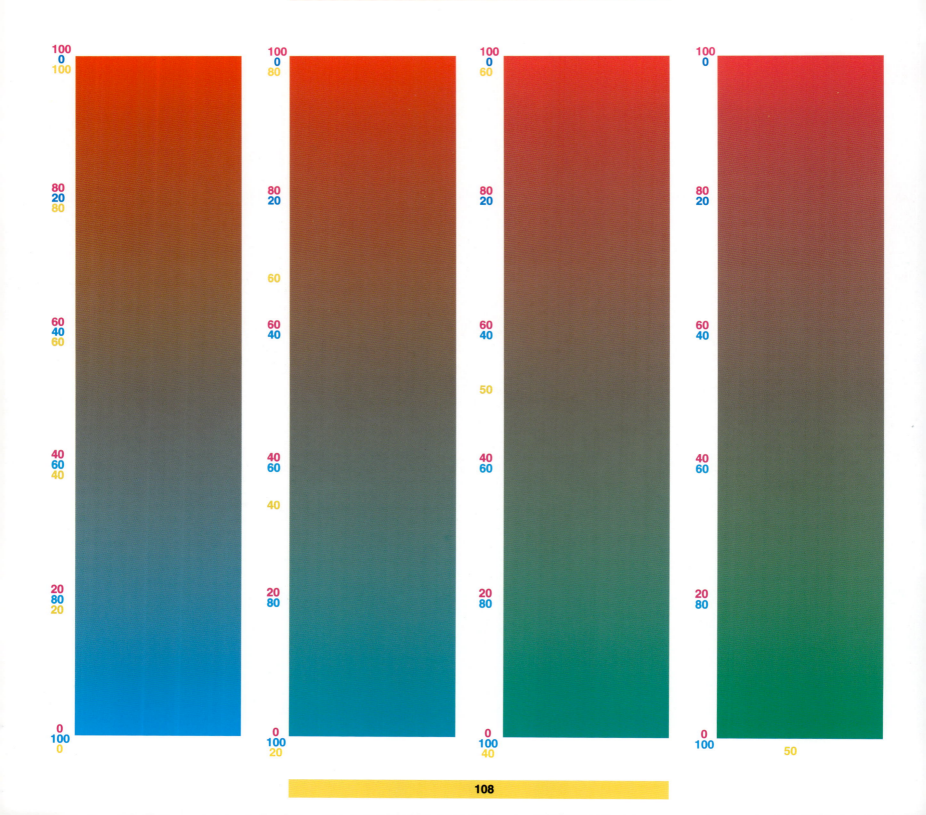

# TYPE & COLOR 2 - BLENDS

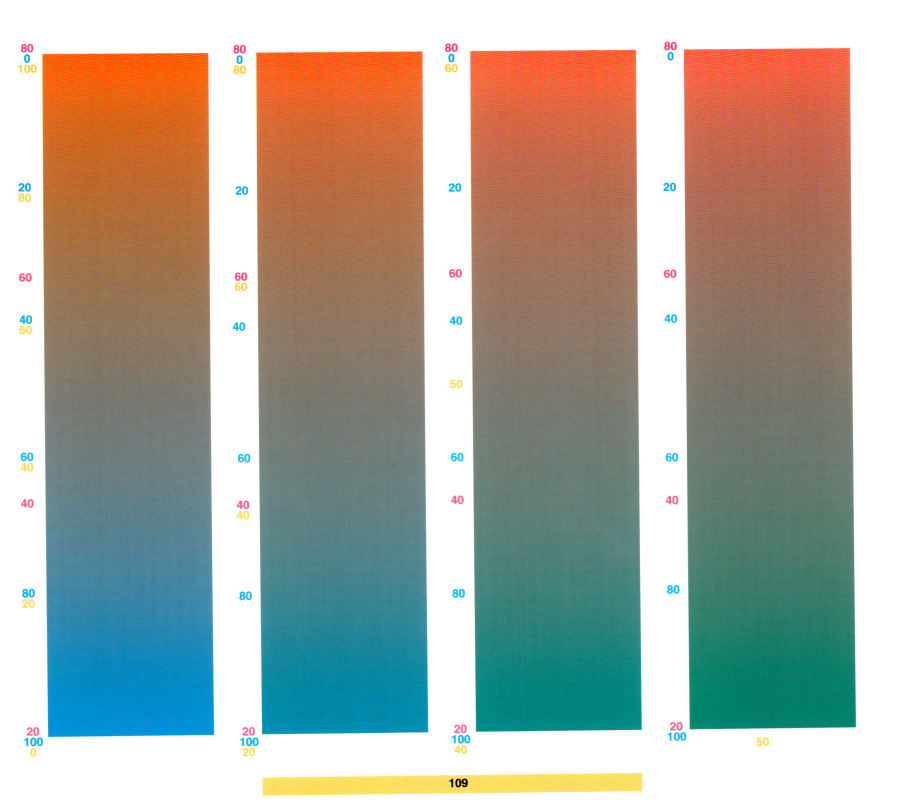

109

**TYPE & COLOR 2 - *BLENDS***

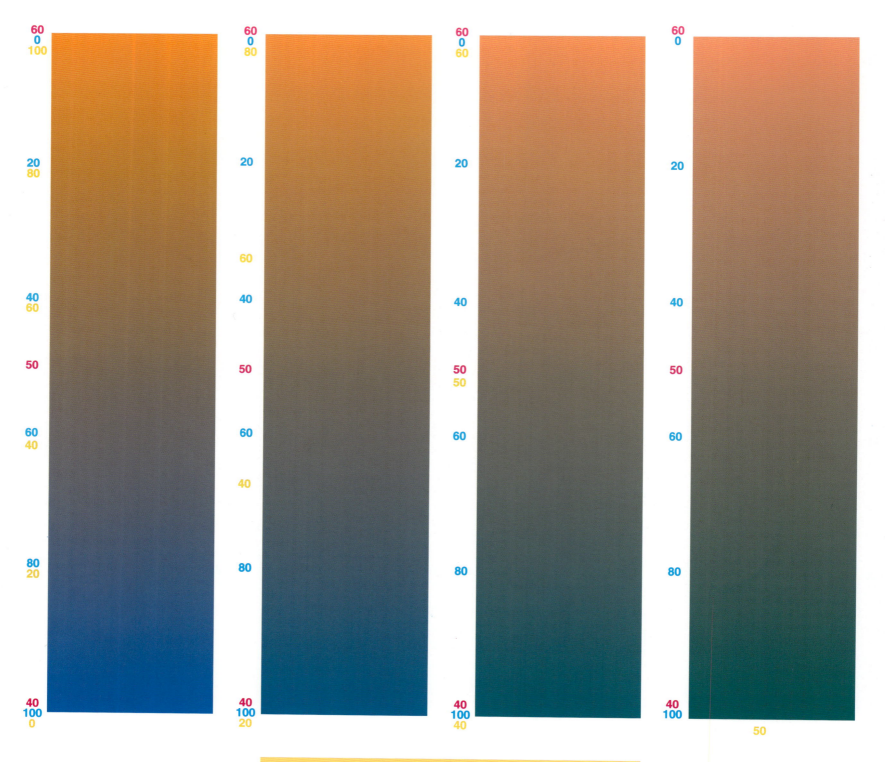

110

# TYPE & COLOR 2 - *BLENDS*

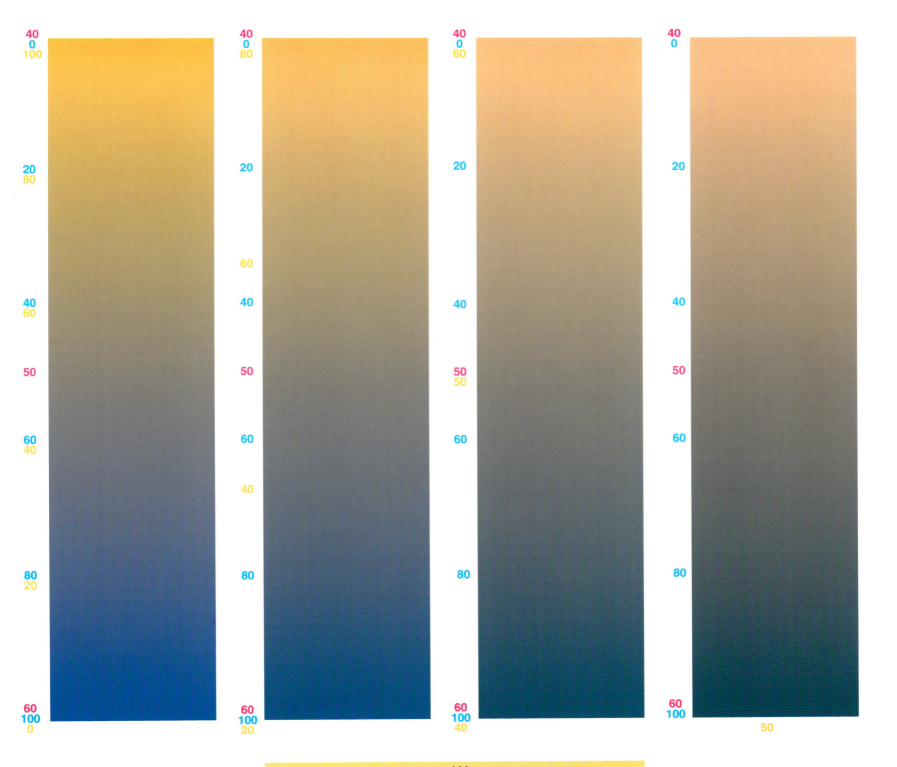

111

**TYPE & COLOR 2 - *BLENDS***

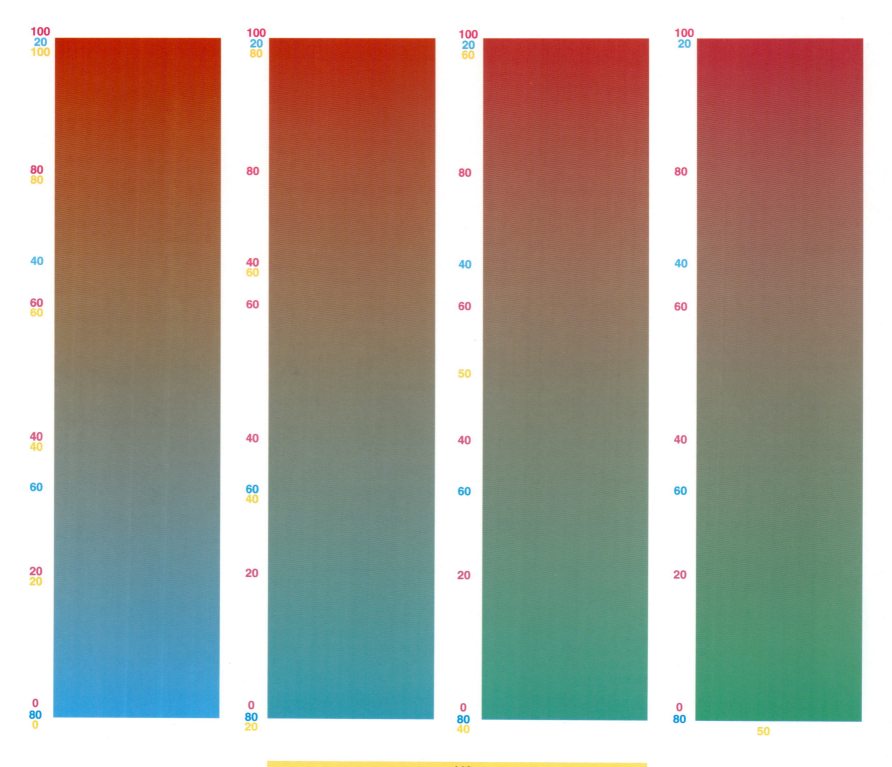

112

**TYPE & COLOR 2 - *BLENDS***

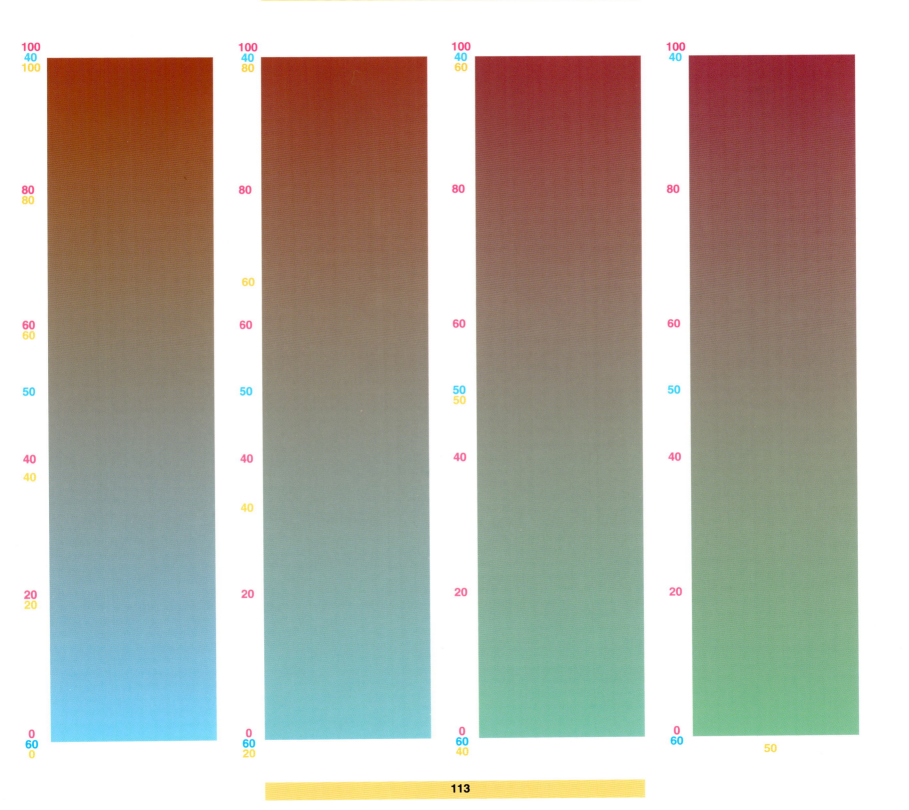

113

# TYPE & COLOR 2 - *BLENDS*

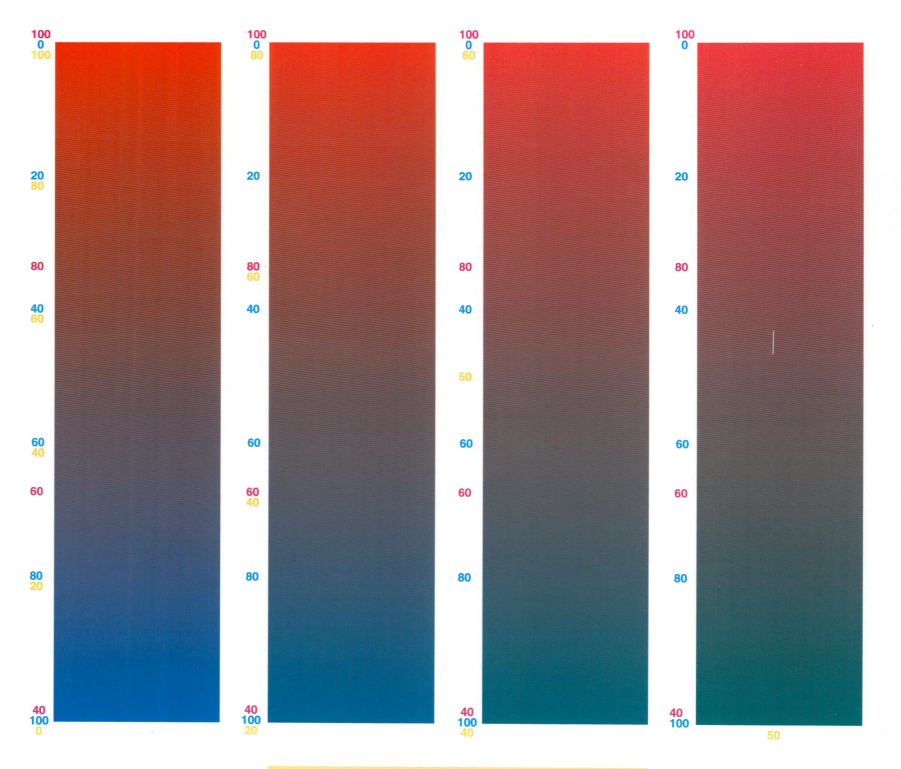

# TYPE & COLOR 2 - *BLENDS*

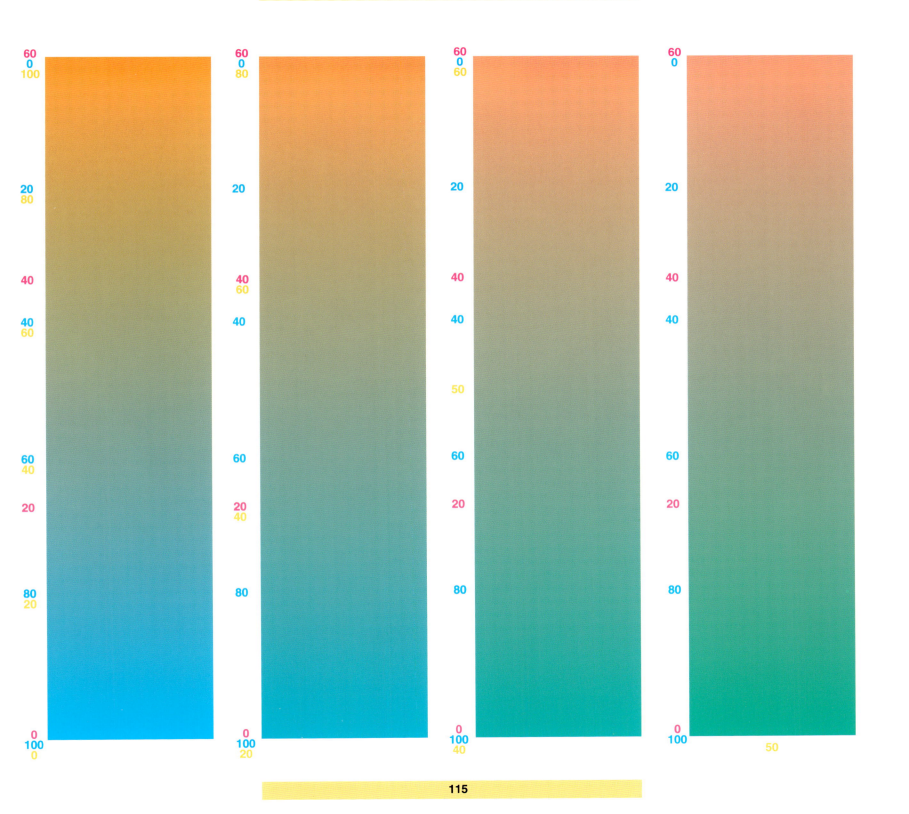

115

**TYPE & COLOR 2 - *BLENDS***

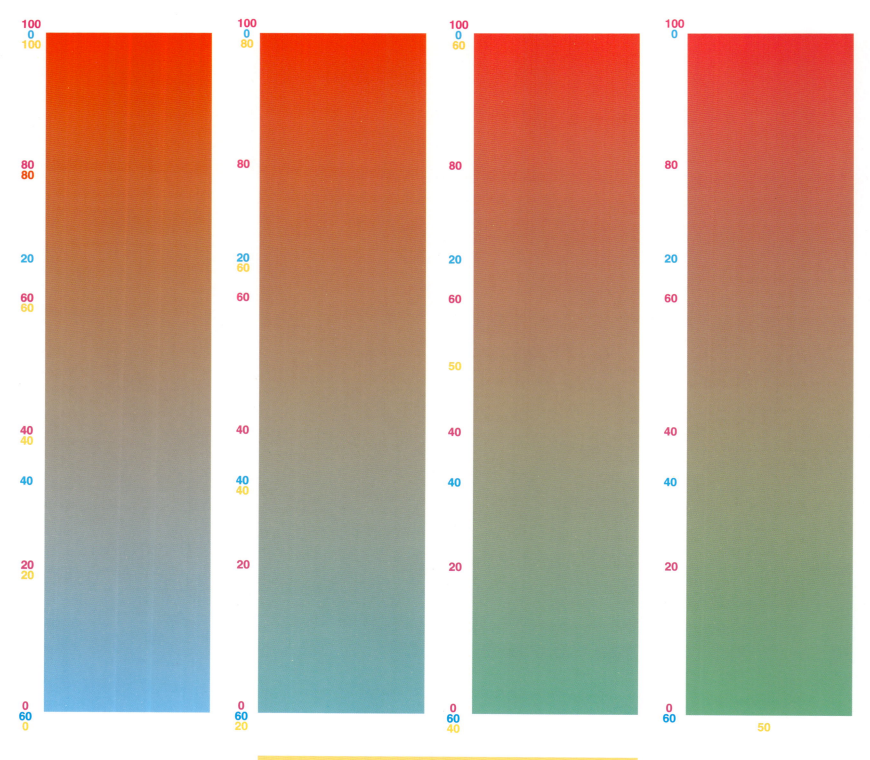

116

# TYPE & COLOR 2 - BLENDS

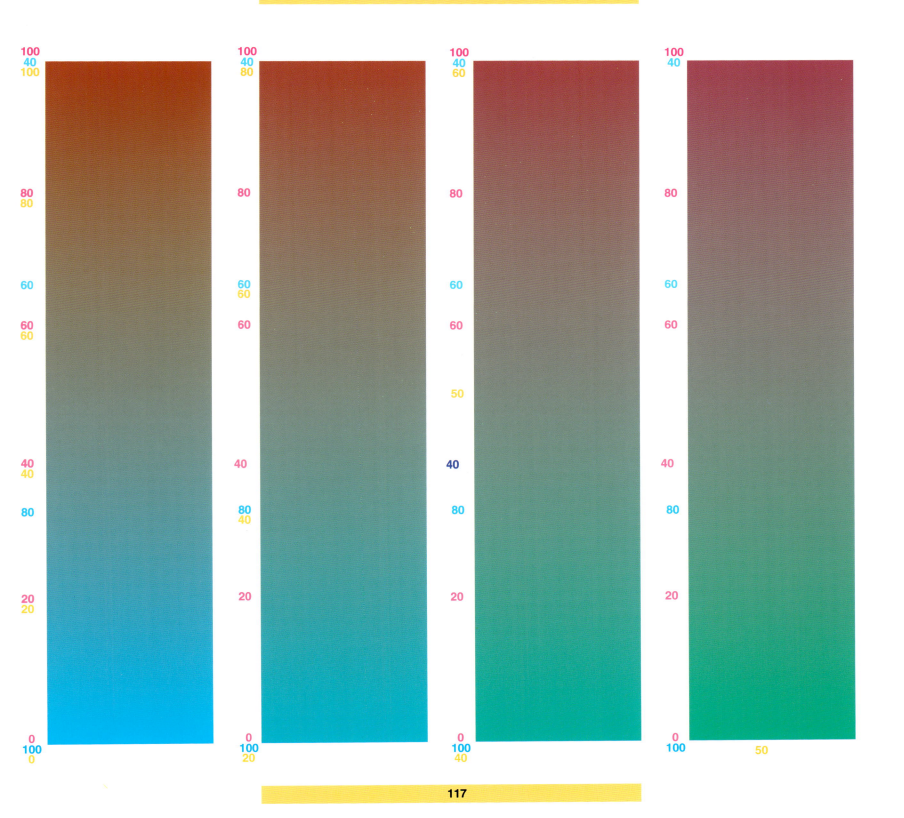

117

# TYPE & COLOR 2 - *BLENDS*

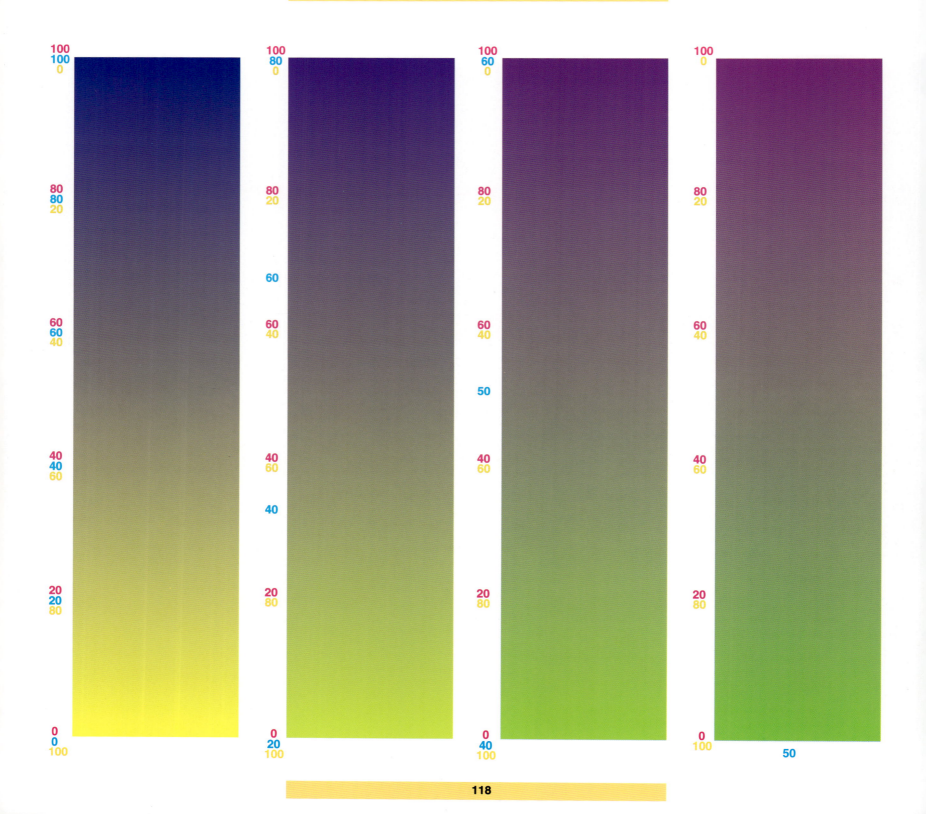

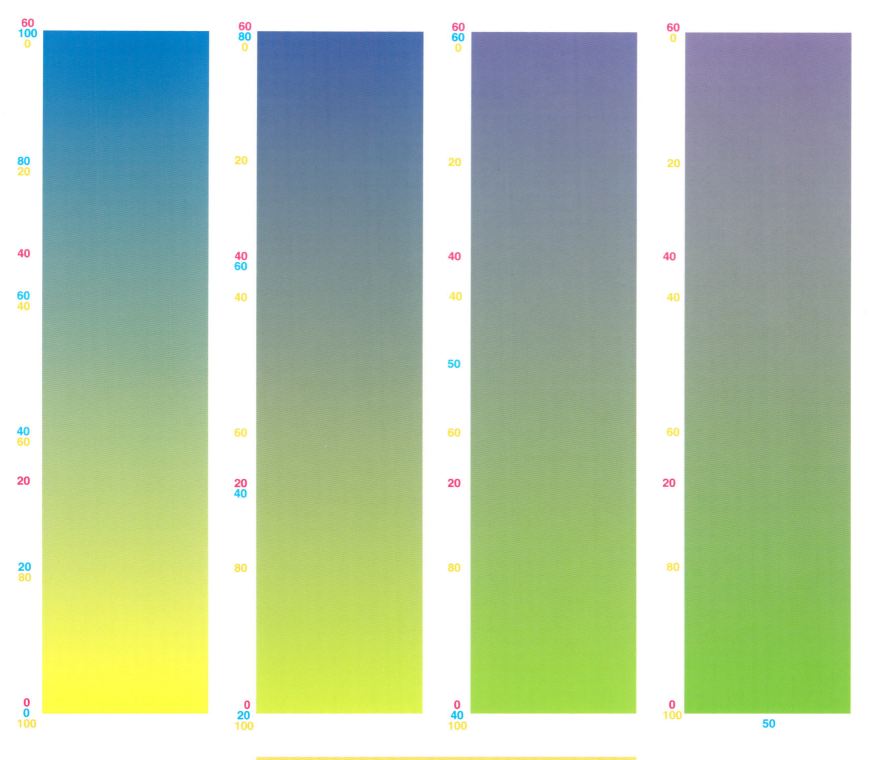

**TYPE & COLOR 2 - *BLENDS***

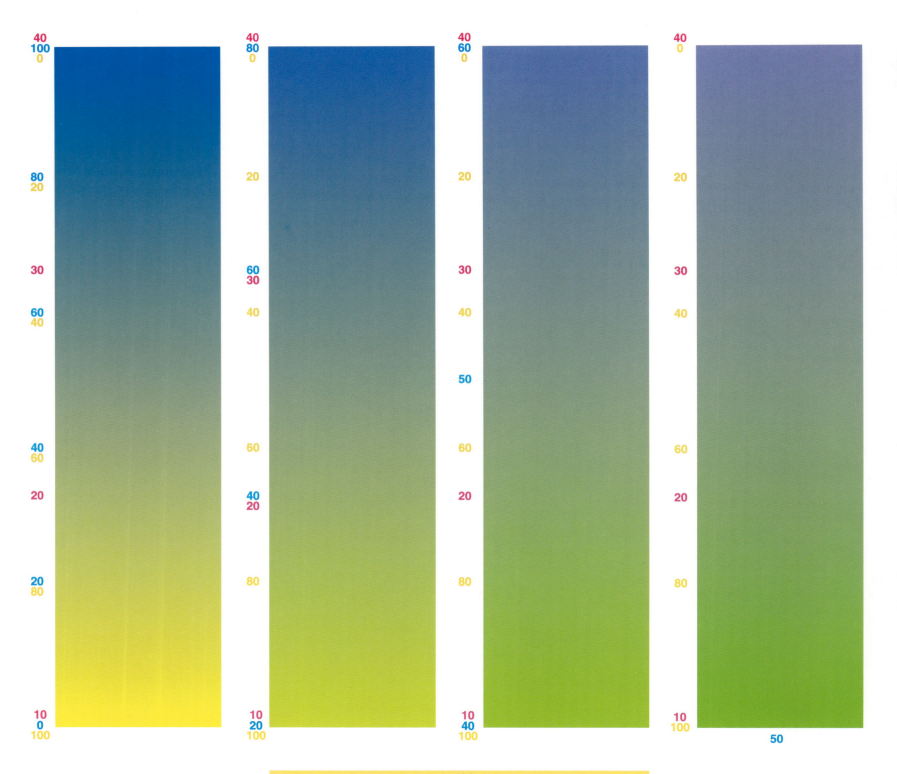

120

# TYPE & COLOR 2 - *BLENDS*

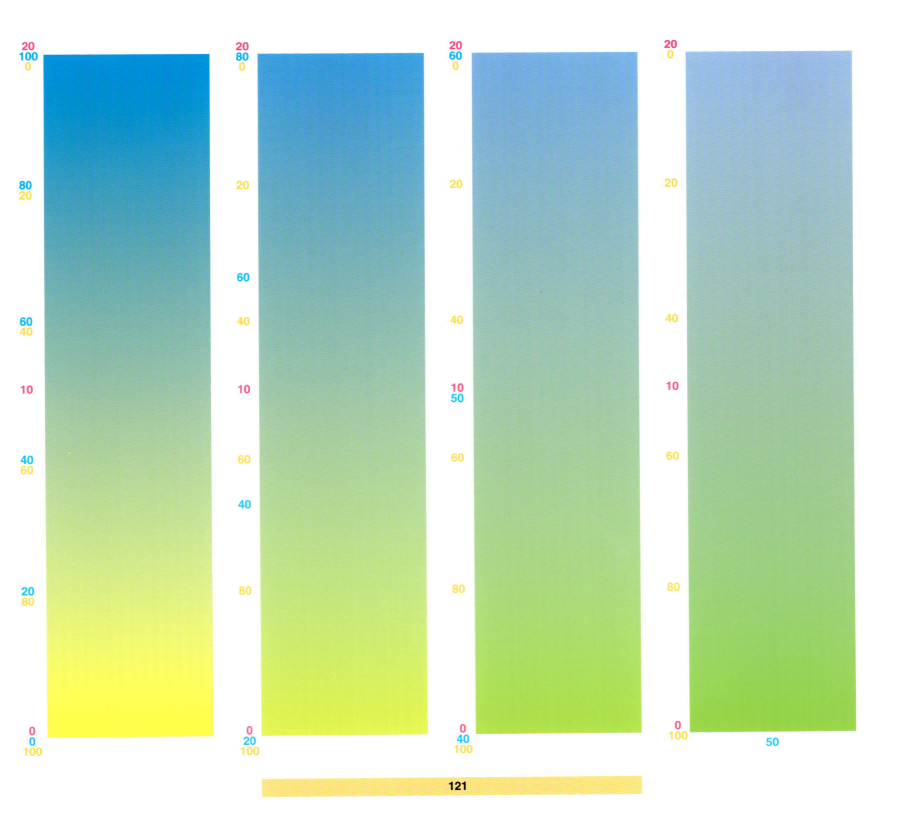

**TYPE & COLOR 2 - *BLENDS***

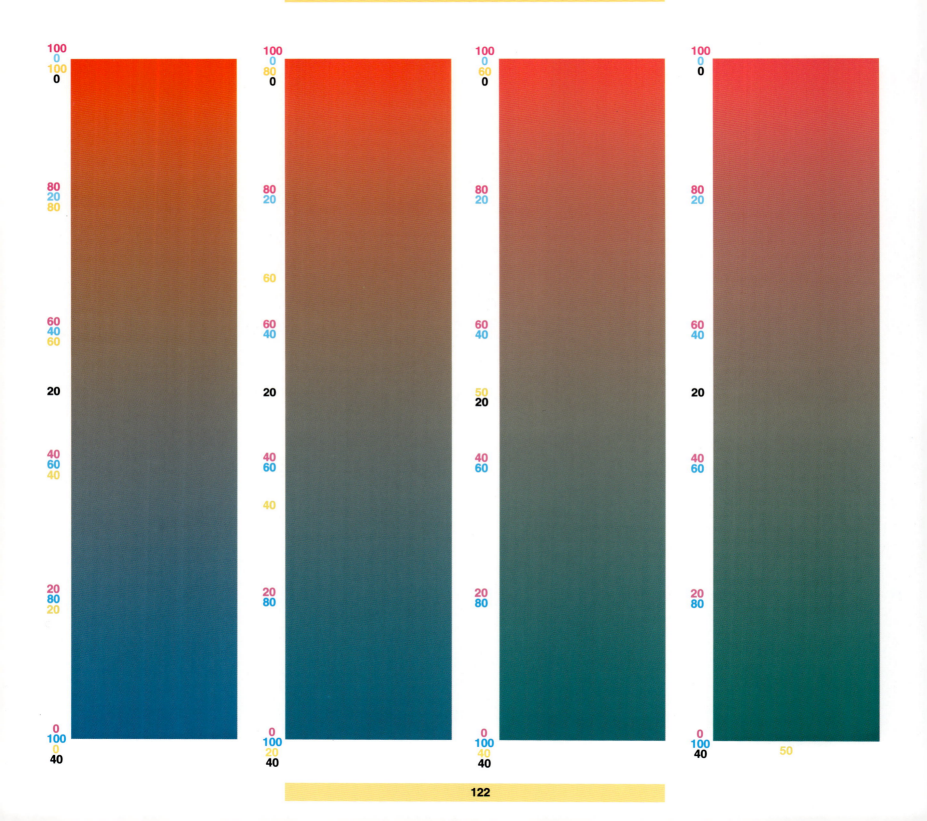

122

# TYPE & COLOR 2 - *BLENDS*

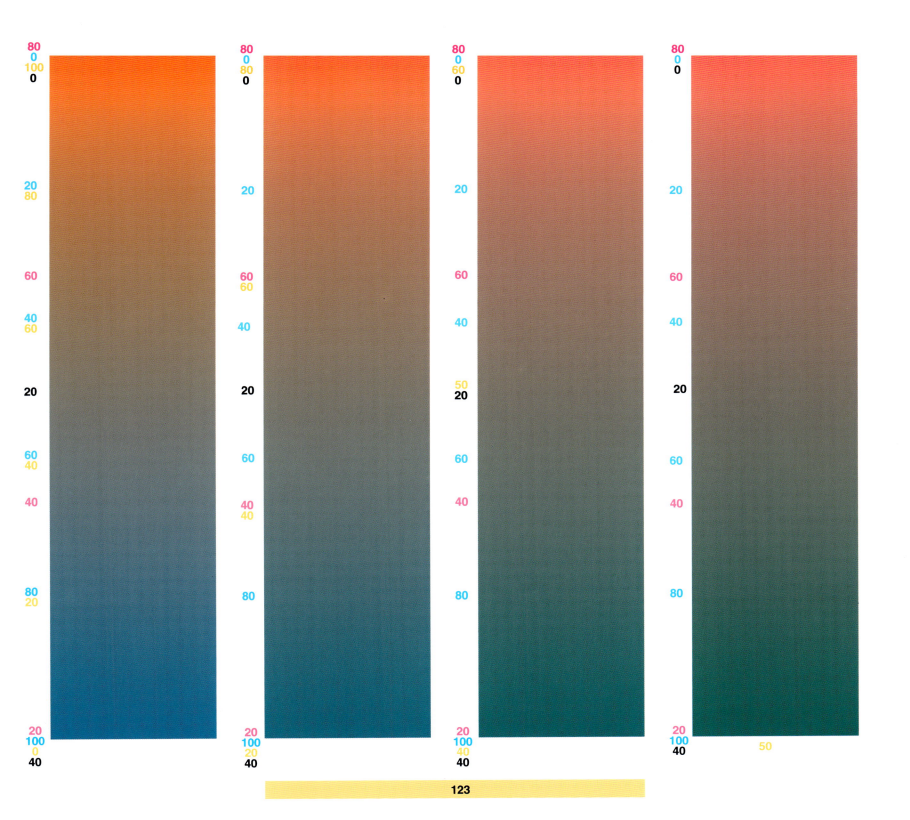

123

# TYPE & COLOR 2 - *BLENDS*

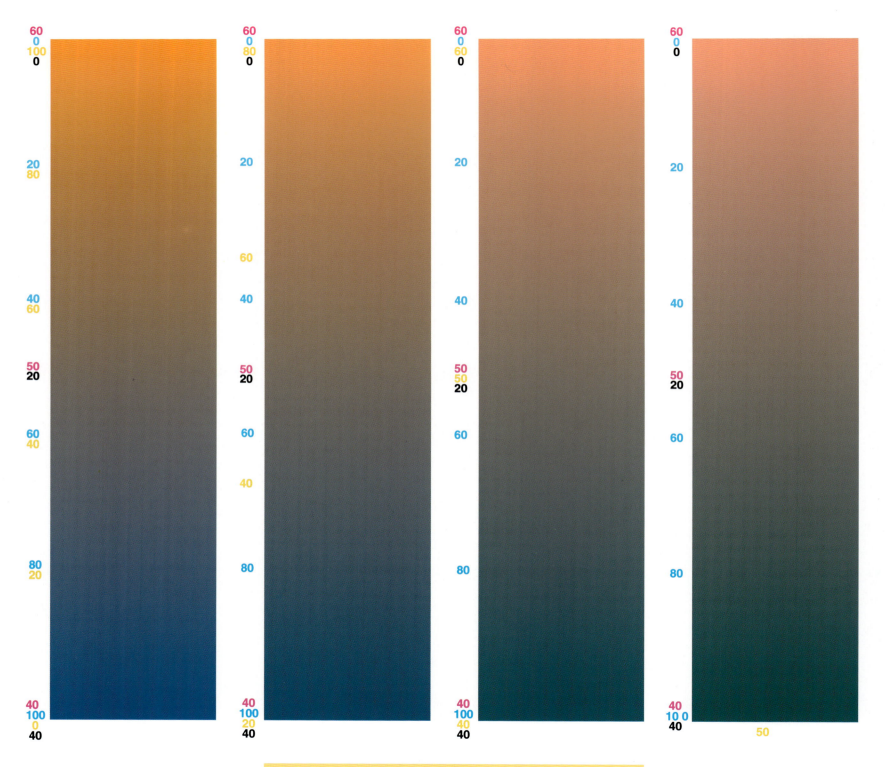

124

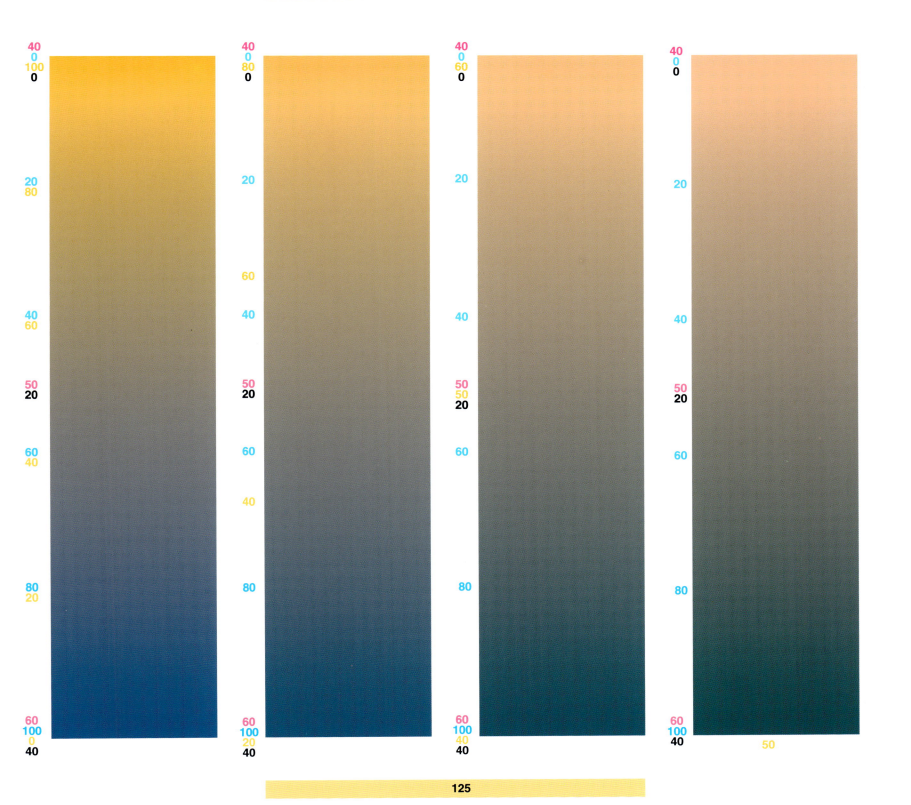

# TYPE & COLOR 2 - *BLENDS*

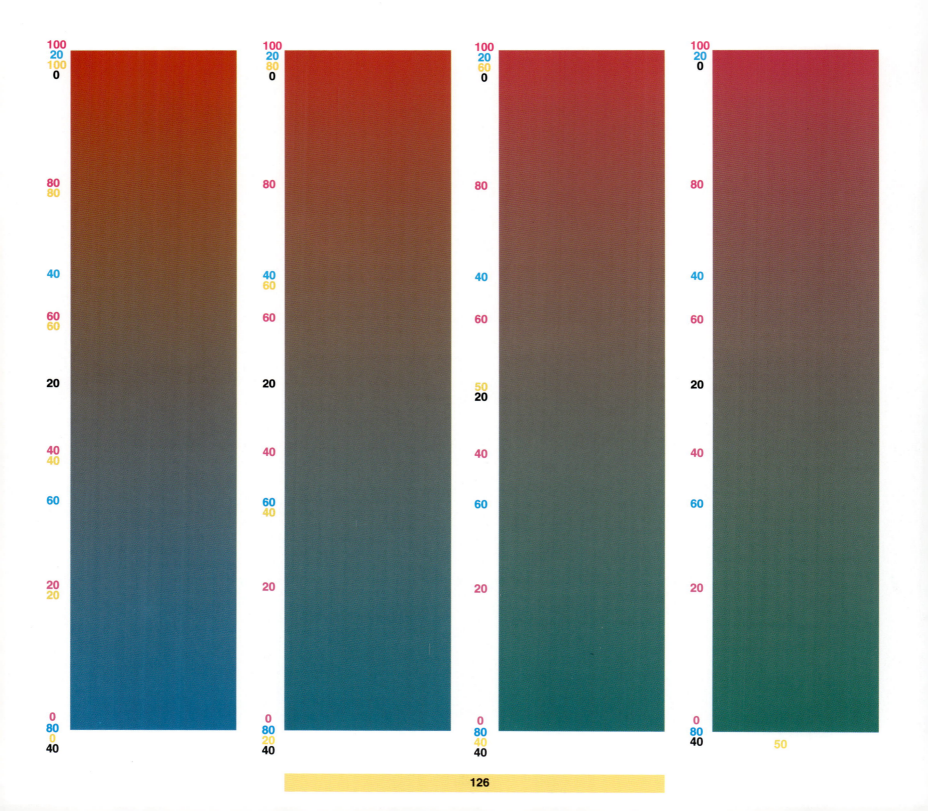

# TYPE & COLOR 2 - *BLENDS*

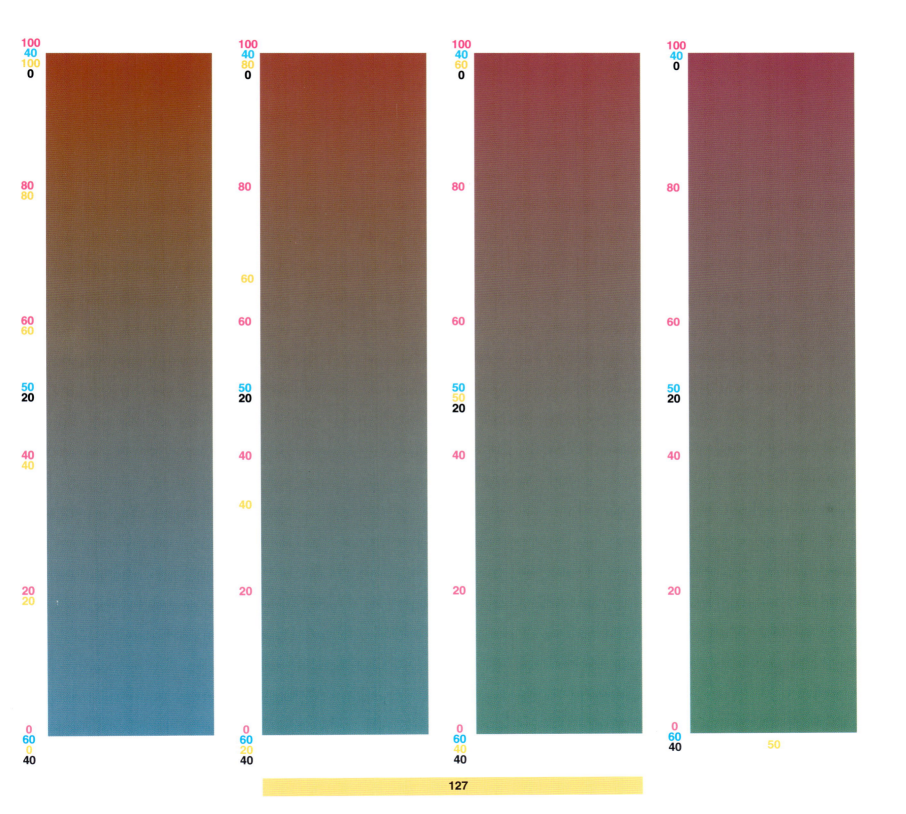

127

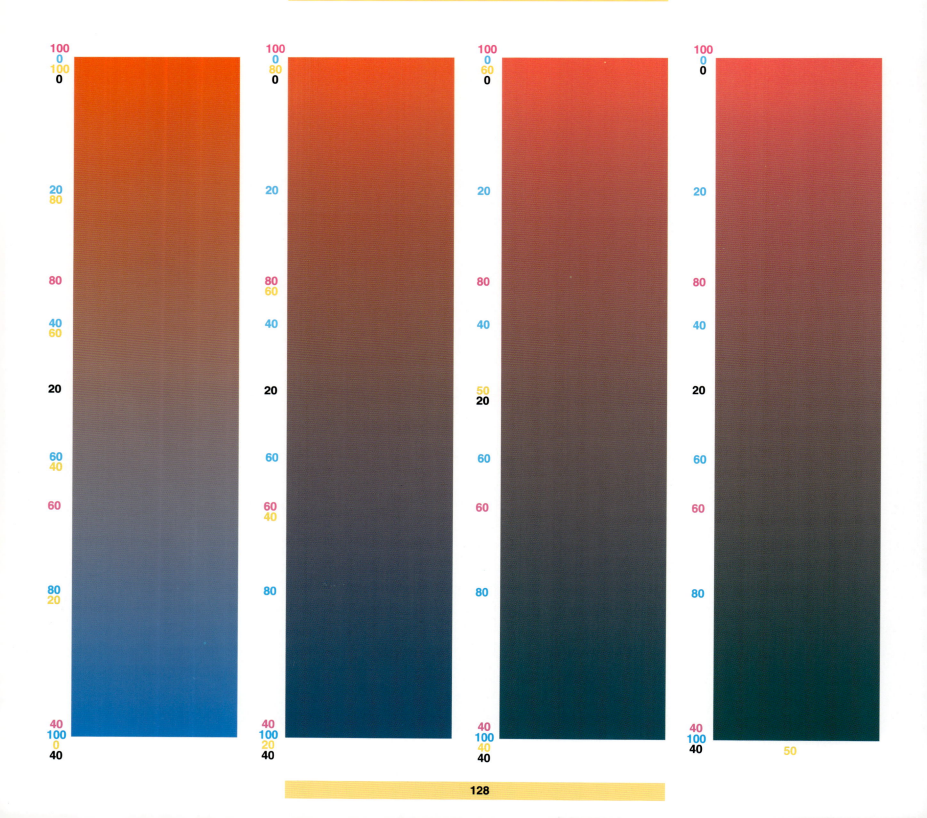

# TYPE & COLOR 2 - *BLENDS*

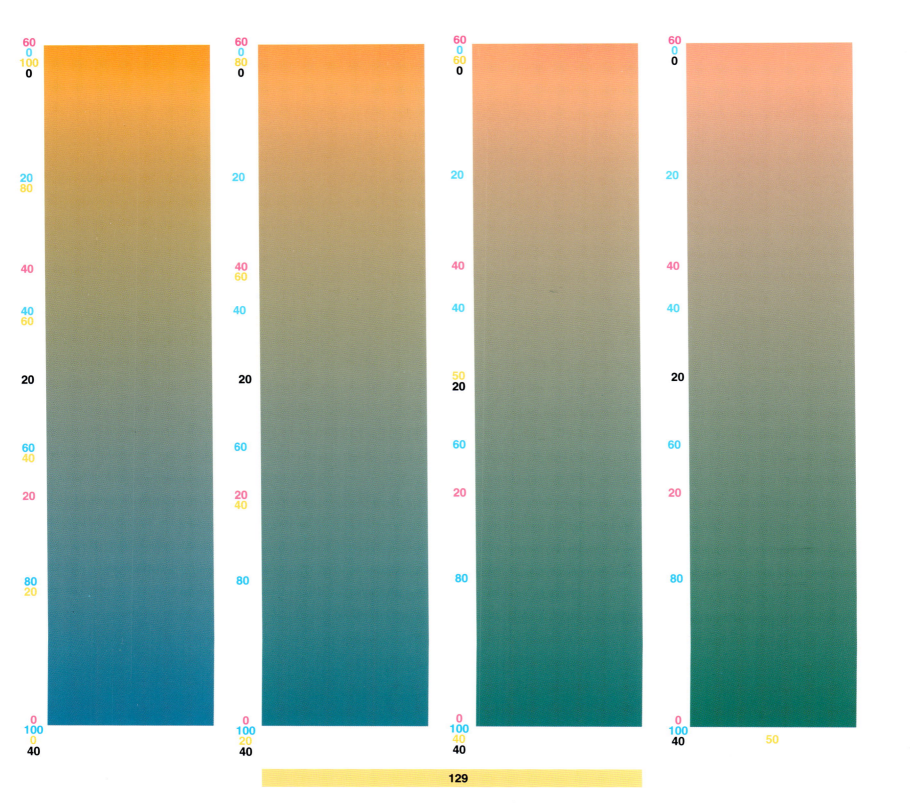

129

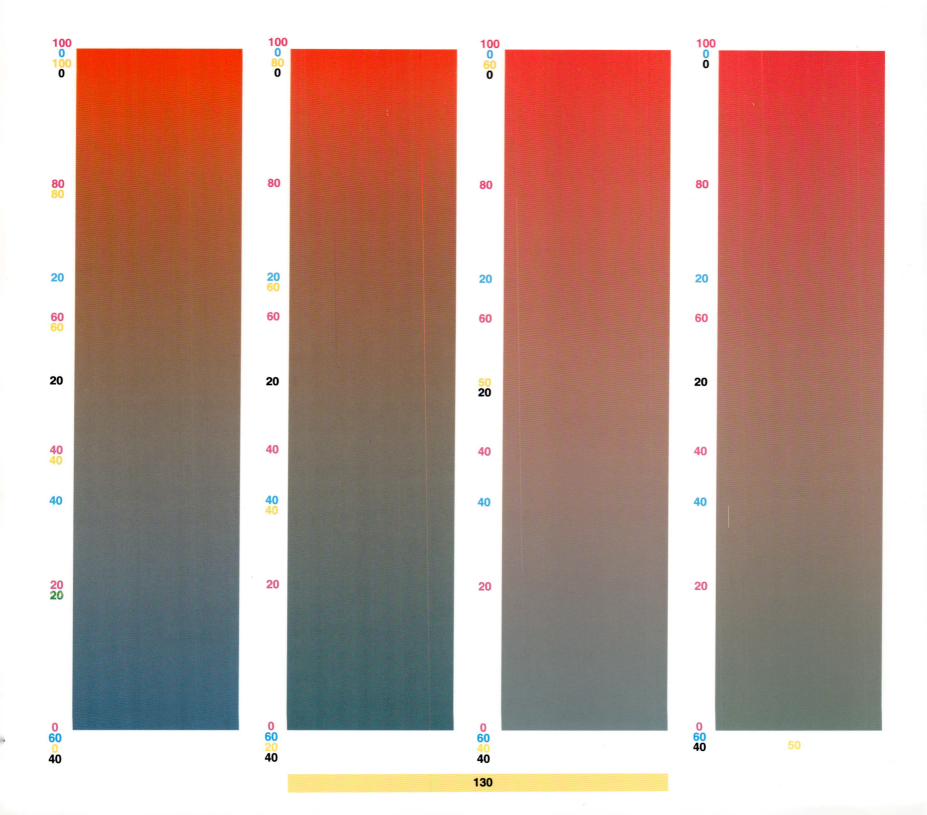

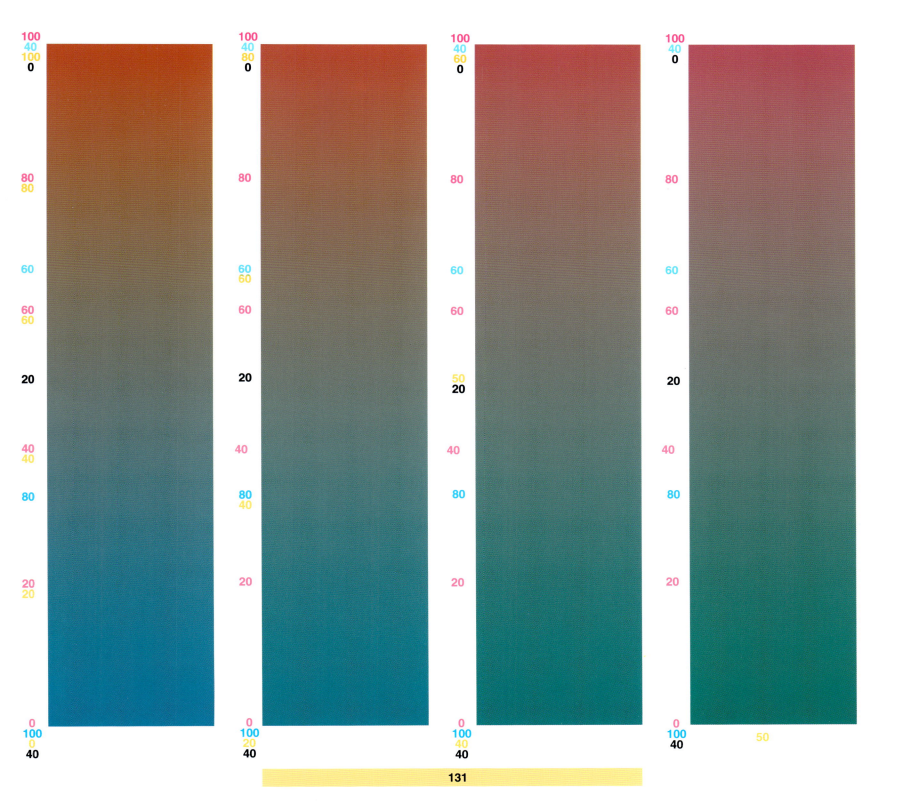

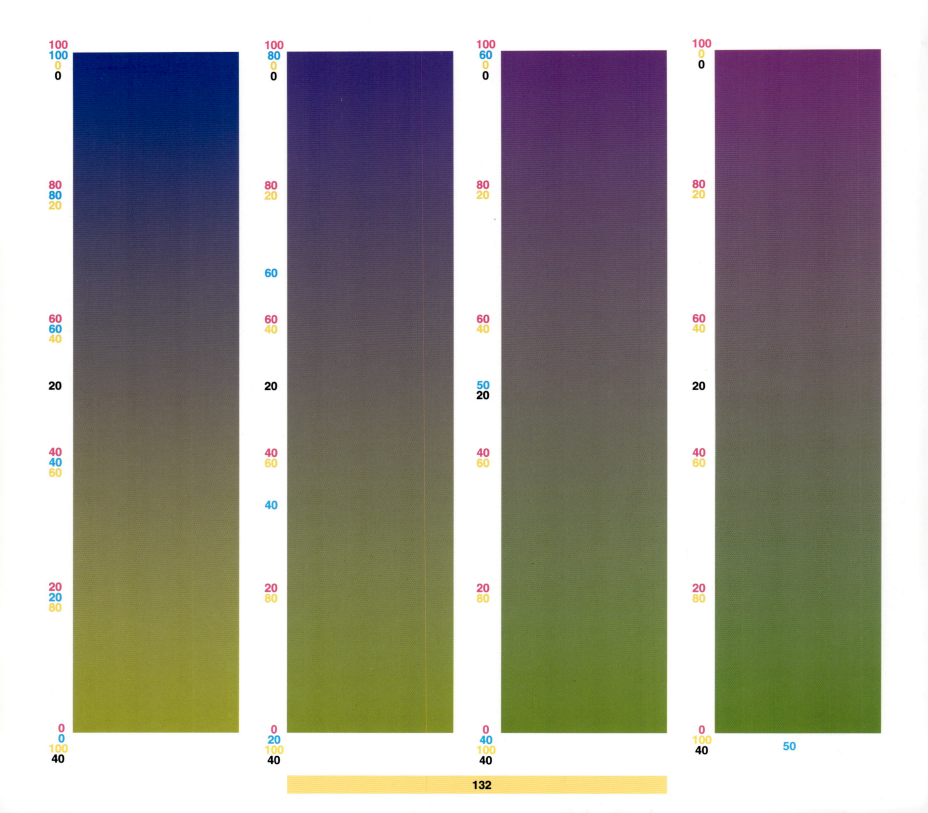

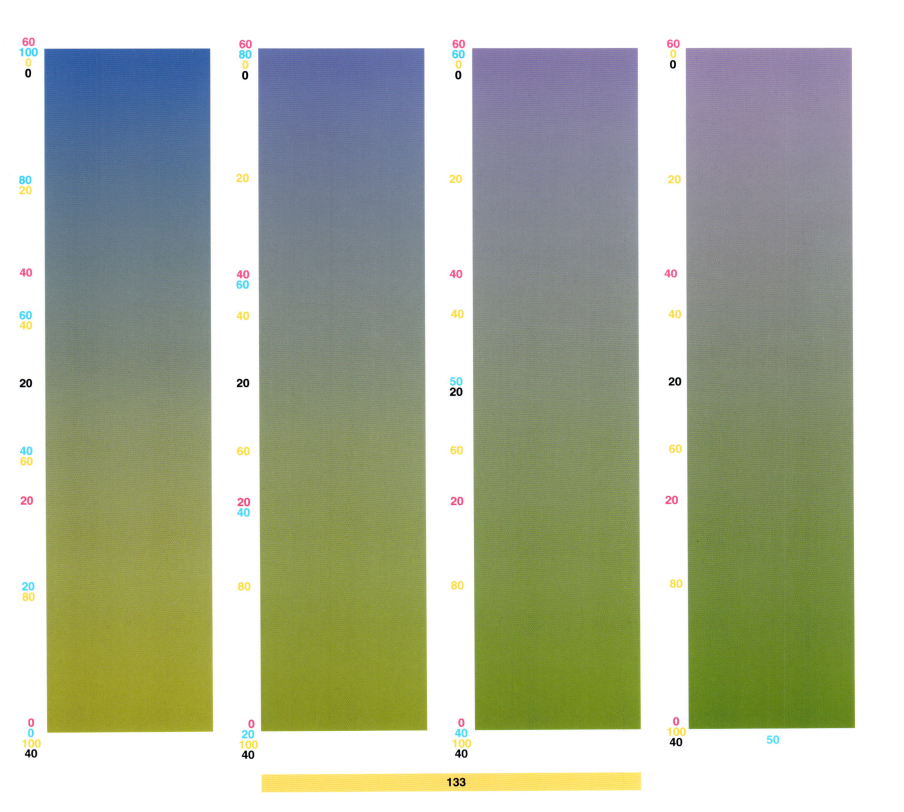

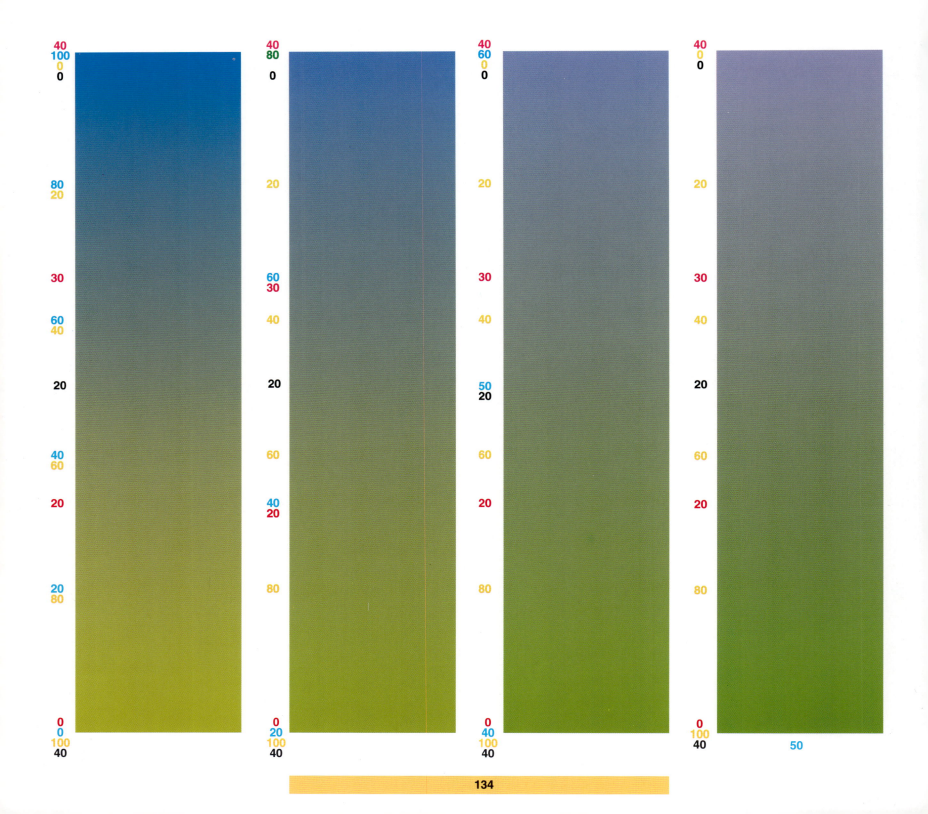

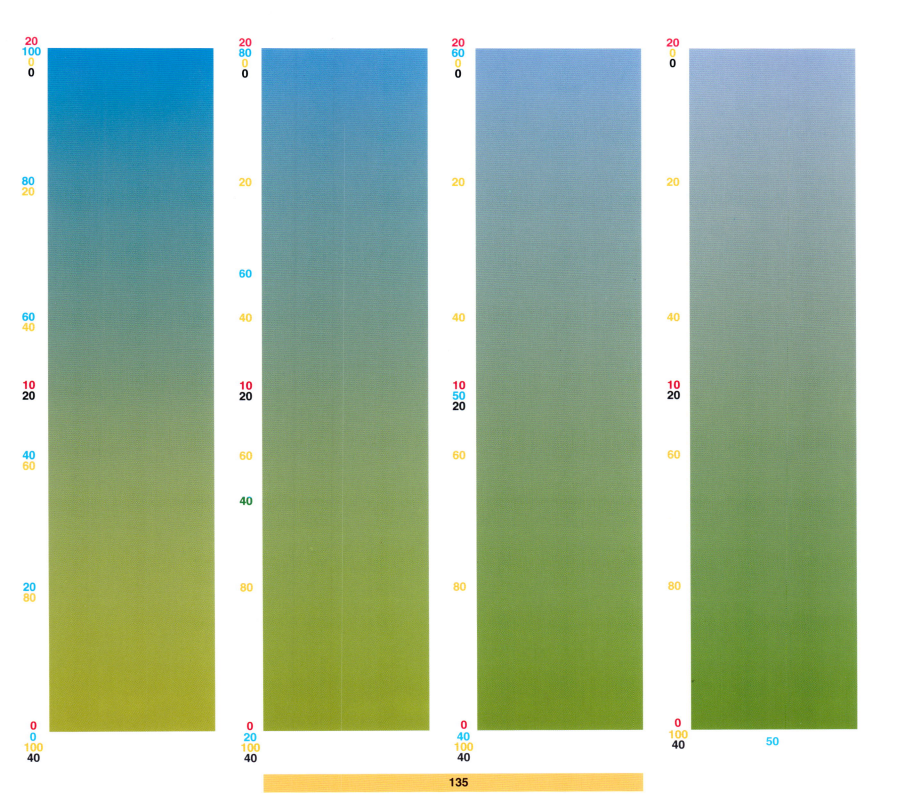

**TYPE & COLOR 2 - *BLENDS***

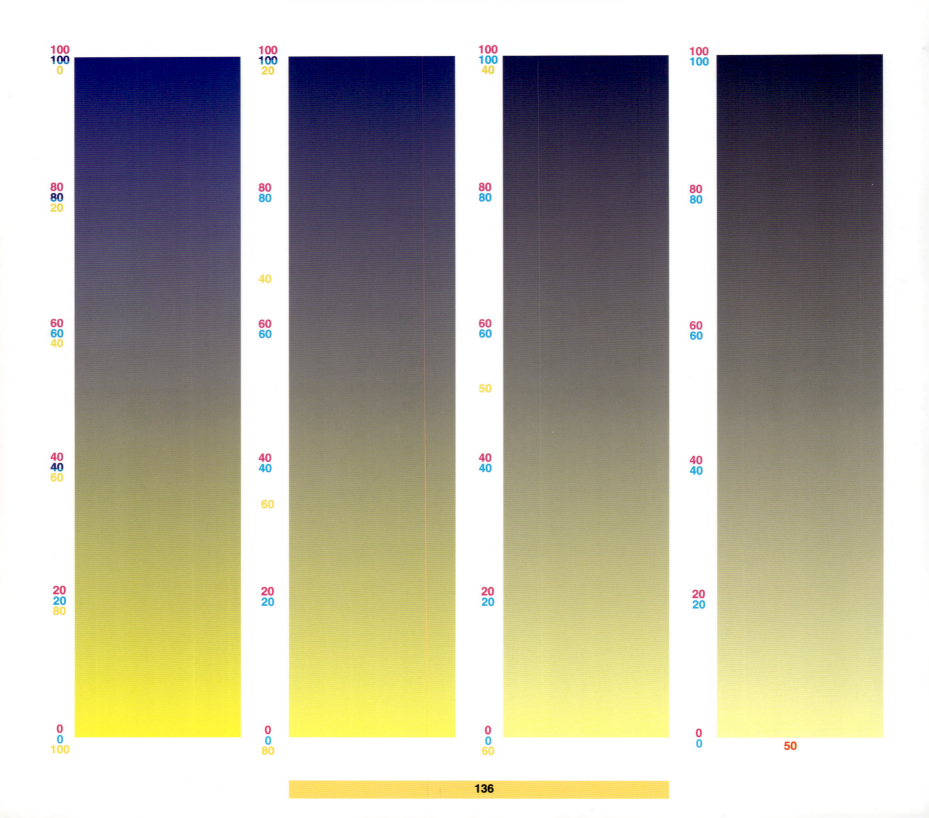

**TYPE & COLOR 2 - *BLENDS***

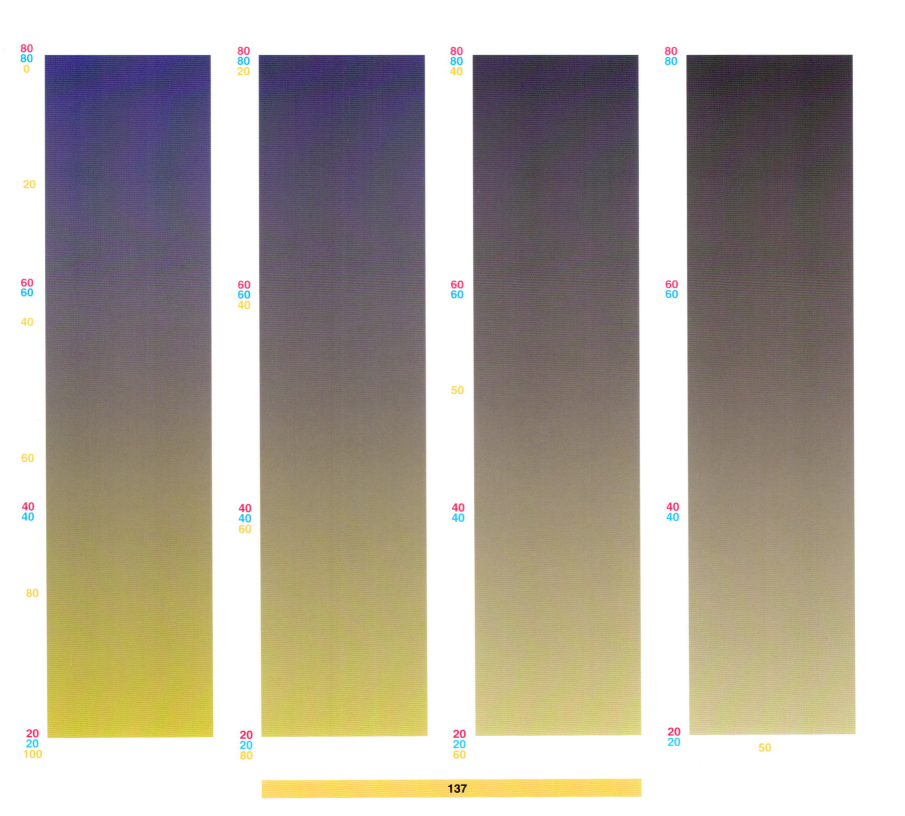

137

# TYPE & COLOR 2 - *BLENDS*

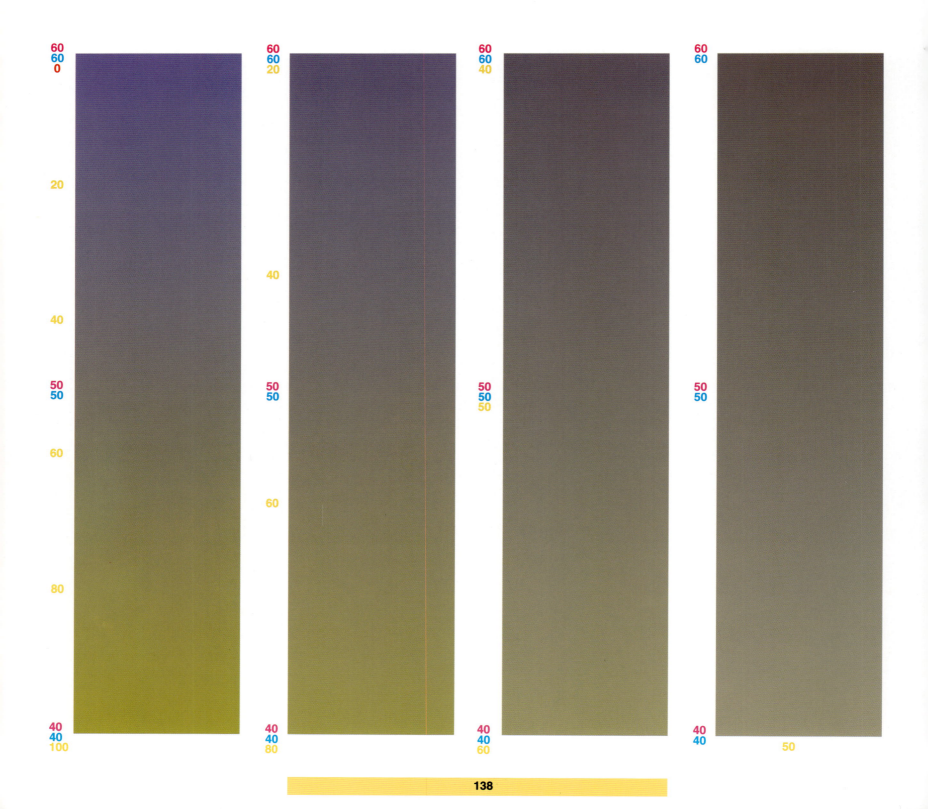

138

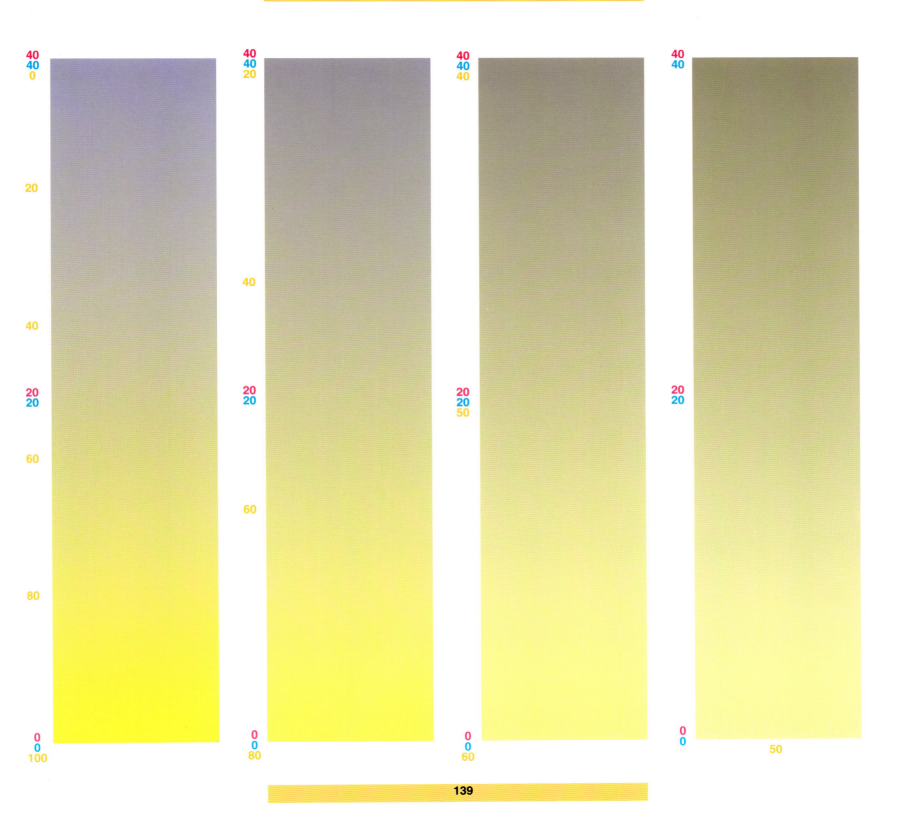

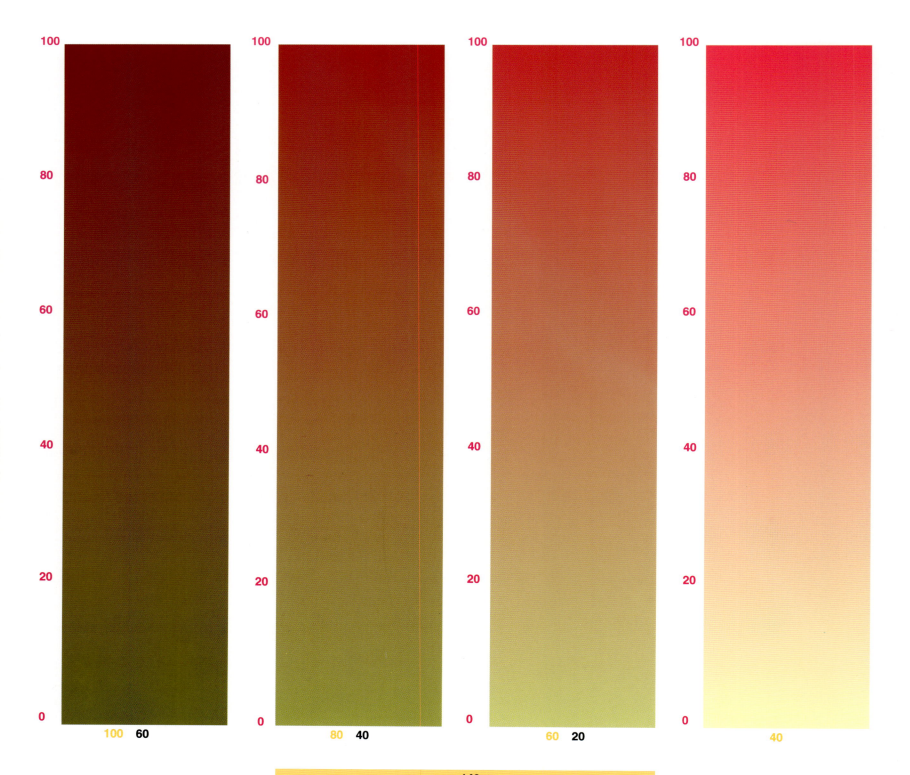

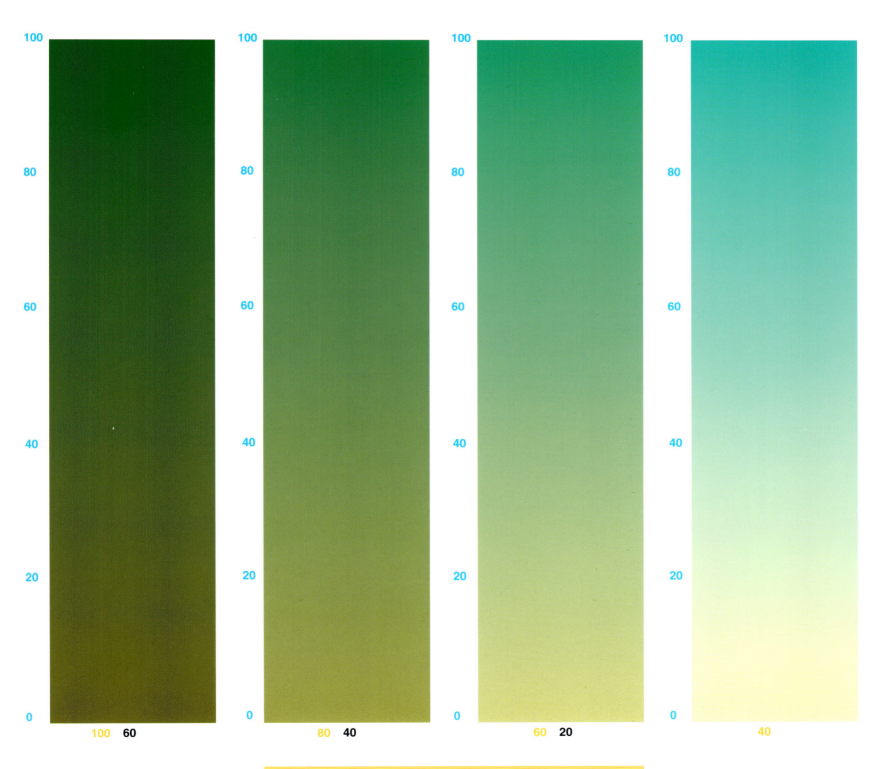

# ALSO AVAILABLE FROM ROCKPORT PUBLISHERS

Rockport Publishers, Inc., 146 Granite Street, Rockport, Massachusetts 01966 • (508) 546-9590 FAX (508) 546-7141

## TYPE & COLOR: A Handbook of Creative Combinations

Graphic artists must perform quickly, creatively and accurately. **Type & Color** enables graphic artists to spec type in color quickly and efficiently. Eleven sheets of color type styles printed on acetate overlays can be combined with hundreds of color bars, making it possible to experiment with thousands of color/type combinations right at the drawing board. In minutes, your eye will rapidly judge what the mind had conceived. 160 pages plus 11 pages of acetate overlays.

160 Pages + 11 acetates  *Hardcover*
$34.95  ISBN 0-935603-19-0

## TYPE IN PLACE: A Thumbnail Approach to Creative Type Placement

This companion guide to **Type & Color** includes 11 acetates with printed type for use with thumbnail images in the book. With this tool, designers can easily envision in thumbnail, ideas for type placement with sample layouts included in the text. This new system allows designers to start from scratch in designing type placements rather than to start from the point of imitation. 60 pages of examples of great type placements are also included.

160 Pages + 11 acetates  *Hardcover*
$34.95  ISBN 0-935603-87-5

## GRAPHIC IDEA NOTEBOOK

The new revised softcover edition of this workhorse book contains 24 all-new pages. This book is a study in graphic design, covering innovative problem-solving, demonstrating techniques to turn routine material into provocative editorial presentation.

216 Pages  *Softcover*
$18.95  ISBN 0-935603-64-6

## MIX & MATCH DESIGNER'S COLORS

Produced by a designer for designers, this book incorporates several features aimed at minimizing guesswork and eliminating errors that are often experienced when using traditional methods of choosing tints for use in four-color process. Extra large swatches show the color extremely clearly, and the ability to turn them over individually allows colors to be compared. From each swatch, the designer can see a variety of color percentages, both knock out and overprint type will appear on that tint, and also how a halftone image appears printed in that color.

300 Swatches  *Hardcover*
$34.95  ISBN 1-56496-009-9

## COLOR HARMONY 2
### 1,000 New Color Combinations for the Designer

The new companion book to **COLOR HARMONY** (which is already in its ninth printing) is the latest step-by-step guide to choosing and combining colors for graphic designers, artists, hobbyists, fashion designers, interior decorators, and anyone else who works with color. **COLOR HARMONY 2** contains new and exciting color combinations, all laid out in easy-to-read swatches and accompanied by color photographs of these new color schemes in action. Select just the right combination to convey a mood or create a dynamic impression from the largest and most thorough color guide available.

160 Pages  *Softcover*
$15.95  ISBN 1-56496-066-8

## 3-DIMENSIONAL ILLUSTRATORS AWARDS ANNUAL IV

The latest series of full-color 3-dimensional illustrations from the Fourth Annual Dimensional Illustrators Awards Show. This year's awards show was better and larger than ever, with an international attendance and categories that included Paper Sculpture, Paper Collage, Clay Sculpture, Fabric Collage, Wood Sculpture, Plastic Sculpture, Mixed Media, and Singular Mediums. 3-D IV is a state-of-the-art sourcebook that offers the most extensive collection of its kind in one magnificent volume.

256 Pages  *Hardcover*
$59.95  ISBN 1-56496-058-7

## AIRBRUSH ACTION 2
### The Best New Airbrush Illustration

This remarkable collection, compiled by Airbrush Action Magazine and Rockport Publishers, boasts the most unique group of airbrush work by the top US airbrush illustrators ever assembled. Introducing the definitive volume of airbrush images that range from the sublime to the humorous. This full-color book exhibits over 400 carefully selected works.

**AIRBRUSH ACTION 2** also features an insightful introduction by Clifford Stieglitz, publisher of Airbrush Action magazine.

192 Pages  *Hardcover*
$34.95  ISBN 1-56496-067-6

## CD PACKAGING & GRAPHICS 2
### The Best Promotional and Retail Packaging

A follow up to the highly-successful first edition, this new book presents the most inspiring designs for the latest in music packaging and media. The CD format has come into its own, and CD packaging has evolved into a flourishing art form. Included are CD covers, CD booklets, screen-printed images on CDs, and unusual and innovative packaging designs. This book features the best work by prominent U.S. and international designers. It is an excellent sourcebook of graphic design, package design, typography, illustration, photography, and printing techniques. Collectors, music aficionados, even vinyl loyalists will find new and innovative takes on music packaging.

192 Pages  *Hardcover*
$39.95  ISBN 1-56496-068-4

## LABEL DESIGN 4
### The Best New U.S. and International Design

**LABEL DESIGN 3** was critically acclaimed for its unique editorial and reproduction quality. **LABEL DESIGN 4** continues that excellence. It is a showcase of the best up-to-the-minute work in label designs. Labels from the following areas will be included: food, snacks, beverages, wines, beer, liquor, health and beauty aids, consumer goods, media products, and much more. Award-winning package designs from all over the world are featured in this full-color sourcebook. This homage to contemporary labels provides useful inspiration to the packaging designer.

240 Pages *Hardcover*
$49.95 ISBN 1-56496-069-2

## GRAPHIC DESIGN: CHICAGO

Following the successful format of **GRAPHIC DESIGN: NEW YORK**, this new full-color volume pays an overdue homage to the top design talent working in the Windy City today. This midwestern metropolis graces us with some of the most formidable creativity today, including the work of Thirst, Concrete Design, Liska Associates, and Lipson Associates. The carefully selected firms have been chosen based upon their distinctive contributions to consumer, corporate, and publication design. The talent showcased here transcends "regional" boundaries and explores new frontiers in design.

224 Pages *Hardcover*
$49.95 ISBN 1-56496-071-4

## SIGN DESIGN GALLERY

Compiled with the editors of Sign of the Times magazine, this full-color showcase book features winners from their annual signage competition. This year's entries include electric, glass, illuminated, carved, hanging, freestanding, sign systems, plus many more new and unique concepts in the field of sign design. There are over 400 cutting-edge sign samples included.

Judged by some of the top international sign professionals with experience from around the globe, SIGN DESIGN GALLERY offers the very latest and very best in environmental graphics today. This full color reference book is guaranteed to spark creativity in the reader.

192 Pages *Hardcover*
$39.95 ISBN 1-56496-070-6

## THE BEST OF COLORED PENCIL 2

This richly illustrated book showcases the best submissions from the first Colored Pencil Society of America Competition. Also included are selections from members of the Society that display a broad range of subjects and styles. From photorealistic renderings to abstracts and graphic illustrations, this book captures the medium's versatility for creating "drawings" and "paintings."

This definitive collection demonstrates why the humble pencil has gone beyond preliminary sketches and outlines and taken its place in the world of professional illustration and fine art. More than an introduction to colored pencils, this book features the ultimate results obtainable with a dry pigment.

**BEST OF COLORED PENCIL 2** is a comprehensive reference for the professional or emerging artist/illustrator and is an important sourcebook for designers and art directors.

160 Pages *Hardcover*
$24.95 ISBN 1-56496-072-2

## COMPUTER GRAPHICS:
### The Best Computer Art & Design

The talent in this volume will astonish and inspire every designer. This tribute to electronic design reveals how computers have revolutionized the look of today's media. Categories include Magazines, Packaging, Posters, Broadcast Design, Fine Arts, Technical Illustration, and much more. Several techniques are presented and explored, such as scanned and manipulated photographs, drawings, illustrations, and graphic designs. This book features work from over 100 of the most talented designers, illustrators, and fine artists working with state-of-the-art electronic design systems.

160 Pages *Softcover*
$34.95 ISBN 1-56496-015-3

## LETTERHEAD & LOGO DESIGNS 2
### Creating the Corporate Image

The most exciting and effective current designs for corporate identity packages including letterheads, business cards, envelopes, and stationery supplies are presented. **LETTERHEAD & LOGO DESIGNS 2** showcases the latest in ideas for the graphic designer looking to create a corporate image. This definitive full-color volume offers effective concepts that create dazzling corporate campaigns.

256 pages *Hardcover*
$49.95 ISBN 1-56496-006-4

## DESKTOP PUBLISHER'S EASY TYPE GUIDE:
### The 150 Most Important Typefaces

There are thousands of different type styles available to the owners of desktop publishing systems, and more being created daily. How does one choose which to purchase? This book will not only help you make those decisions, but will show you how to get the most benefit from the type styles you choose. From the neophyte designer, to the desktop newcomer this guide will prove a valuable resource.

176 Pages *Softcover*
$19.95 ISBN 1-56496-007-2

## THE CREATIVE STROKE:
### Communication with Brush and Pen in Graphic Design

This book presents an in-depth look at the most creative and innovative uses of freehand imagery in design, specifically those with brush and pen. While the current push for computer-generated graphics has revolutionized the design industry, there is a renewed interest in the uniqueness of the freehand, especially since once produced, the images can be scanned into the computer. Designers can use this book to refer to what's currently being produced in both brush/pen graphics and calligraphy. Materials includes Media Advertising, Direct Mail, Posters, Book Covers, Packaging, and Corporate ID. Experience the magic of freehand art!

192 Pages *Hardcover*
$39.95 ISBN 0-935603-61-1